LOGO &LETTERHEAD

ROCKPORT
PUBLISHERS

ROCKPORT PUBLISHERS, INC.
ROCKPORT, MASSACHUSETTS

First published in the United States of America by:
Rockport Publishers, Inc.
146 Granite Street
Rockport, Massachusetts 01966
Telephone: (508) 546-9590
Fax: (508) 546-7141

Other Distribution by:
Rockport Publishers, Inc.
Rockport, Massachusetts 01966

Cover Contributors:
(Clockwise from top left)
Pentagram
Emery/Poe Design
Manhattan Design
Eilts Anderson Tracy
Rick Eiber Design
David Carter Design
Ben & Jerry's Art Department

ISBN 1-56496-161-3

10 9 8 7 6 5 4 3

Printed in Hong Kong

INTRODUCTION

The Yellow Pages have over one million business advertisers, all fighting for visibility on the same yellow background. What is it that makes us decide to call Bill's Plumbing over Phil's Plumbing? Usually nothing more than a creative logo.

Logos and letterheads, although small in size, can be as effective as an entire advertising campaign. The first thing any new business owner creates is a logo. This small design not only reflects a company's identity but can create an image for a company that grows beyond the product itself. For instance, the Nike Air logo has become a symbol for more than just a sneaker, the Coca Cola logo represents more than a can of soda.

This volume of the *Design Library* series presents the best logos and letterheads from the past decade, providing an inspirational collection of the most basic as well as the most important and influential graphic elements for any business.

These pages demonstrate the fundamental and essential ability of the graphic designer; to create effective logos and letterheads—very small designs with very big voices.

DESIGN FIRM	Turpin Design Associates		**DESIGN FIRM**	Michael Stanard Inc.
ART DIRECTOR	Tony F. Turpin		**ART DIRECTOR**	Michael Stanard
DESIGNERS	Joesph E. Whisnant, Tony F. Turpin		**DESIGNER**	Lisa Fingerhut
CLIENT	Cambridge Commercial Carpet		**CLIENT**	Caledonian Inc.
PAPER/PRINTING	One color plus foil on Strathmore Writing Kromekote Cover		**PAPER/PRINTING**	Four colors on Strathmore Writing

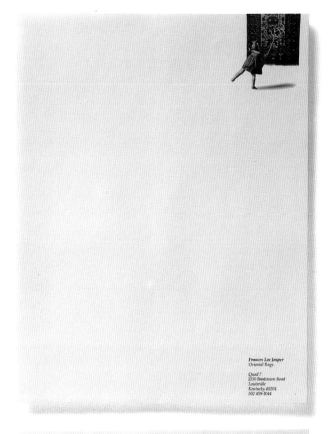

DESIGN FIRM	Mark Palmer Design		**DESIGN FIRM**	McCord Graphic Design
ART DIRECTOR	Mark Palmer		**ART DIRECTOR**	Walter McCord
DESIGNER	Mark Palmer		**DESIGNER**	Walter McCord
CLIENT	Baby ZZZ's/Pawley Island Pub		**CLIENT**	Jasper Oriental Rugs
PAPER/PRINTING	Three colors on Strathmore Writing Wove		**PAPER/PRINTING**	Tritone plus one color on Neenah Classic Crest

SAN FRANCISCO CLOTHING 975 Lexington Avenue New York, N.Y. 10021 (212) 472-8740

Howard Partman

SAN FRANCISCO CLOTHING
975 Lexington Avenue New York, N.Y. 10021 (212) 472-8740

SAN FRANCISCO CLOTHING
975 Lexington Avenue New York, N.Y. 10021

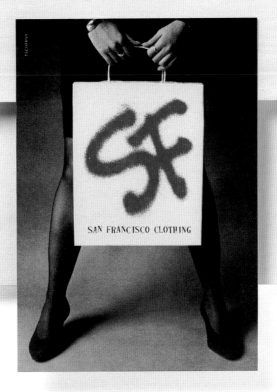

DESIGN FIRM	George Tscherny, Inc.
ART DIRECTOR	George Tscherny
DESIGNER	George Tscherny
CLIENT	San Francisco Clothing

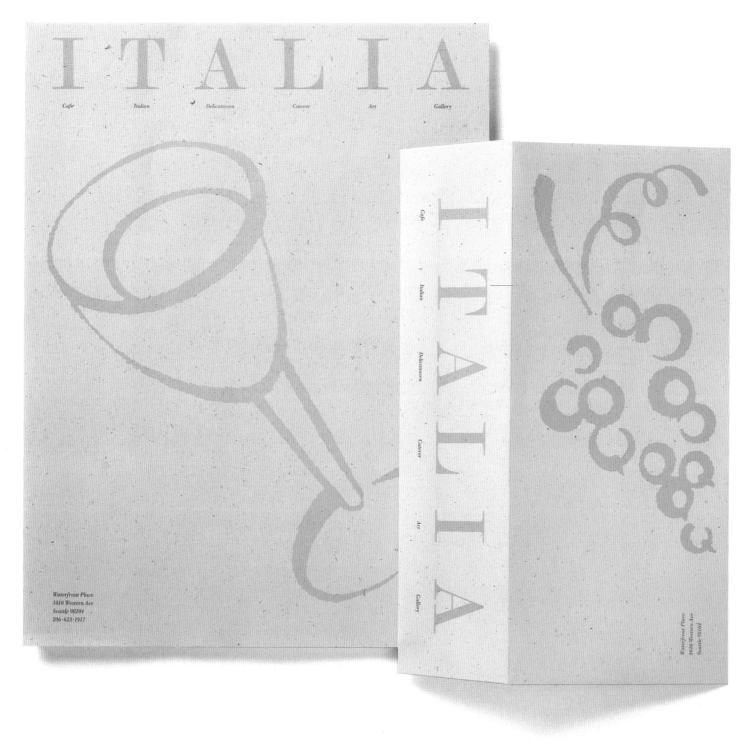

DESIGN FIRM Hornall Anderson Design Works
ART DIRECTOR Jack Anderson
DESIGNERS Jack Anderson, Julia LaPine
CLIENT Italia Restaurant
PAPER/PRINTING Three colors on Speckletone

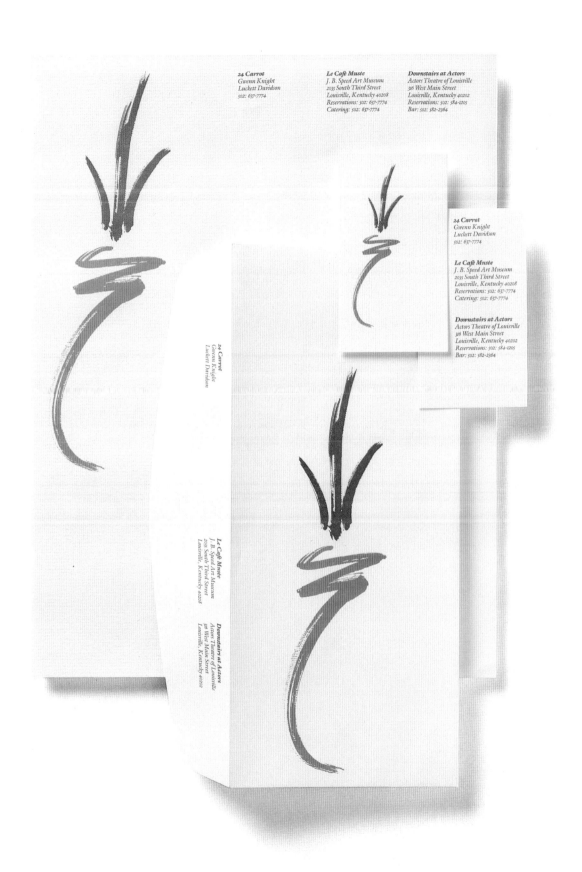

24 Carrot
Gwenn Knight
Luckett Davidson
502: 637-7774

Le Café Musée
J. B. Speed Art Museum
2035 South Third Street
Louisville, Kentucky 40208
Reservations: 502: 637-7774
Catering: 502: 637-7774

Downstairs at Actors
Actors Theatre of Louisville
316 West Main Street
Louisville, Kentucky 40202
Reservations: 502: 584-1205
Bar: 502: 582-2364

24 Carrot
Gwenn Knight
Luckett Davidson
502: 637-7774

Le Café Musée
J. B. Speed Art Museum
2035 South Third Street
Louisville, Kentucky 40208
Reservations: 502: 637-7774
Catering: 502: 637-7774

Downstairs at Actors
Actors Theatre of Louisville
316 West Main Street
Louisville, Kentucky 40202
Reservations: 502: 584-1205
Bar: 502: 582-2364

24 Carrot
Gwenn Knight
Luckett Davidson

Le Café Musée
J. B. Speed Art Museum
2035 South Third Street
Louisville, Kentucky 40208

Downstairs at Actors
Actors Theatre of Louisville
316 West Main Street
Louisville, Kentucky 40202

DESIGN FIRM	McCord Graphic Design
ART DIRECTORS	Walter McCord, Julius Friedman
DESIGNERS	Walter McCord, Julius Friedman
ILLUSTRATOR	Walter McCord
CLIENT	24 Carrot, Inc.
PAPER/PRINTING	Three colors on Strathmore Writing

| | | | | |
|---|---|---|---|
| **DESIGN FIRM** | Page Design, Inc. | **DESIGN FIRM** | Milton Glaser, Inc. |
| **ART DIRECTOR** | Paul Page | **ART DIRECTOR** | Milton Glaser |
| **DESIGNER** | Tracy Titus | **DESIGNER** | Milton Glaser |
| **ILLUSTRATOR** | Tracy Titus | **CLIENT** | Brooklyn Brewery |
| **CLIENT** | California Bound | **PAPER/PRINTING** | Two colors on Weston Merit Bond |
| **PAPER/PRINTING** | Four colors on Strathmore Writing | | |

DESIGN FIRM	Clark Keller	**DESIGN FIRM**	Whitney • Edwards Design
ART DIRECTOR	Neal Ashby	**ART DIRECTOR**	Charlene Whitney • Edwards
DESIGNER	Neal Ashby	**DESIGNER**	Charlene Whitney • Edwards
ILLUSTRATOR	Neal Ashby	**COMPUTER OUTPUT**	In Tandem Design
CLIENT	Chauncey's Chili	**CLIENT**	Mercury Services
PAPER/PRINTING	One color on Kraft Speckletone	**PAPER/PRINTING**	Two colors on Neenah Classic Laid Writing Whitestone

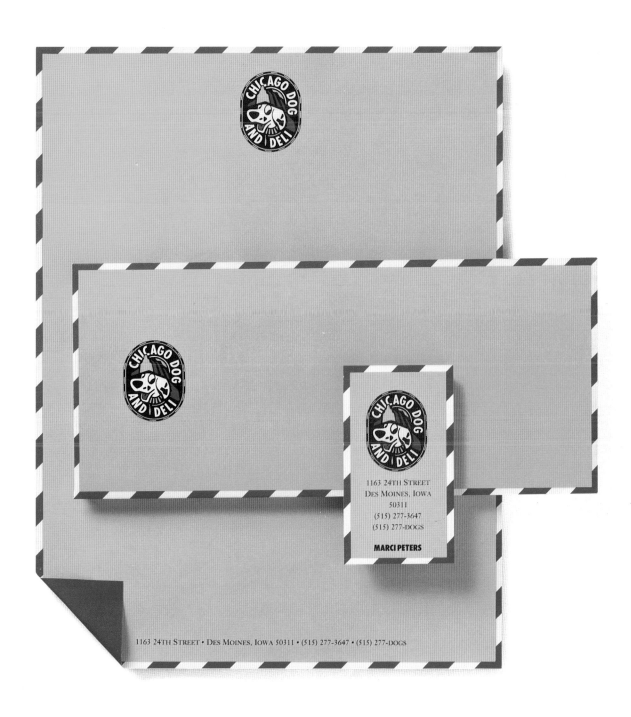

DESIGN FIRM Sayles Graphic Design
ART DIRECTOR John Sayles
DESIGNER John Sayles
CLIENT Chicago Dog & Deli
PAPER/PRINTING Three colors on Neenah Classic Crest

9

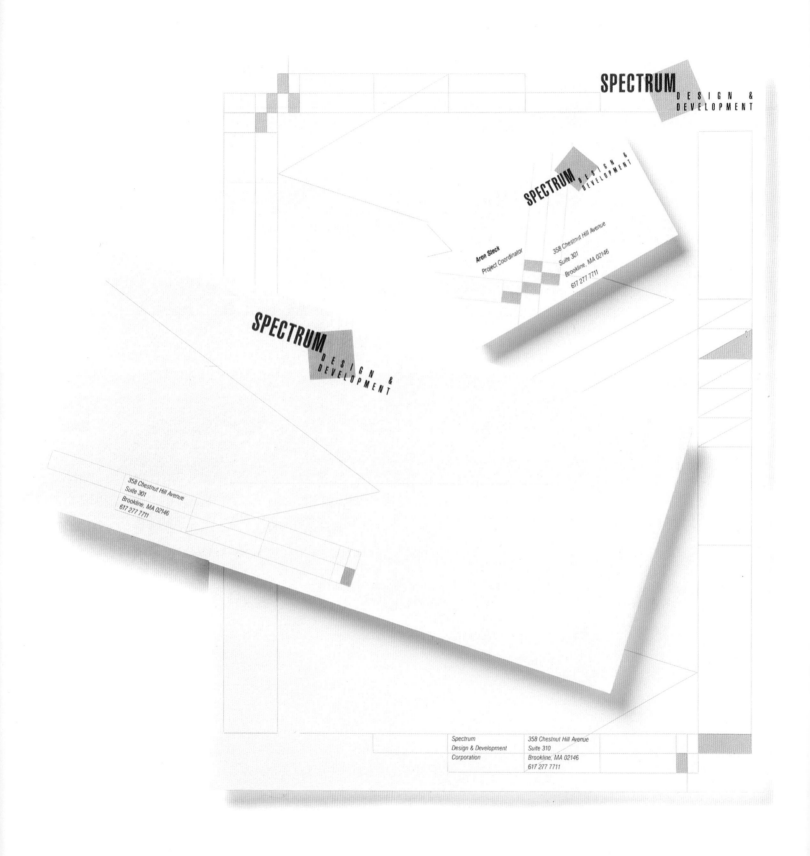

SPECTRUM
DESIGN &
DEVELOPMENT

SPECTRUM
DESIGN &
DEVELOPMENT

Aron Steck
Project Coordinator

358 Chestnut Hill Avenue
Suite 301
Brookline, MA 02146
617 277 7711

SPECTRUM
DESIGN &
DEVELOPMENT

358 Chestnut Hill Avenue
Suite 301
Brookline, MA 02146
617 277 7711

Spectrum
Design & Development
Corporation

358 Chestnut Hill Avenue
Suite 310
Brookline, MA 02146
617 277 7711

DESIGN FIRM Marc English: Design
ART DIRECTOR Marc English
DESIGNER Marc English
CLIENT Spectrum
PAPER/PRINTING Two colors on Strathmore Writing

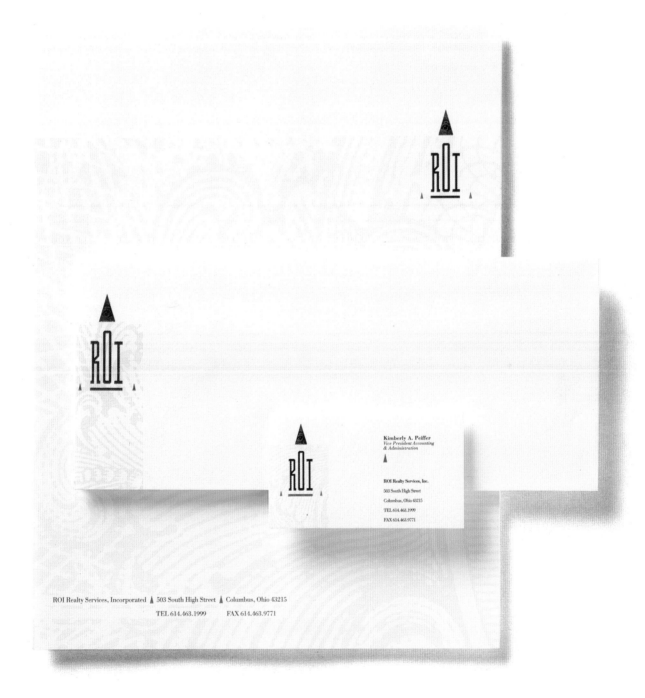

DESIGN FIRM	Integrate, Inc.
ART DIRECTORS	John Galvin, Stephen Quinn
DESIGNERS	John Galvin, Stephen Quinn
CLIENT	ROI Realty Services, Inc.
PAPER/PRINTING	Two colors on Gilbert Writing

DESIGN FIRM	Davies Associates
ART DIRECTOR	Noel Davies
DESIGNERS	Cathy Tetef, Meredith Kamm
CLIENT	Eastern Columbia Building
PAPER/PRINTING	Three colors on Crane's Crest Fluorescent White Wove

DESIGN FIRM	McCord Graphic Design
ART DIRECTOR	Walter McCord
DESIGNER	Walter McCord
ILLUSTRATOR	Melvin Prueitt
CLIENT	Site Research Group
PAPER/PRINTING	Two colors on Simpson Filare

DESIGN FIRM	McCord Graphic Design
ART DIRECTOR	Walter McCord
DESIGNER	Walter McCord
ILLUSTRATOR	Walter McCord
CLIENT	Cash Lewman
PAPER/PRINTING	Two colors on Strathmore Writing

DESIGN FIRM	Creative Works
ART DIRECTORS	David Wright, Bob Jahn
DESIGNERS	David Wright, Bob Jan
CLIENT	The St. James Development Co.
PAPER/PRINTING	Two colors on Gilbert Oxford

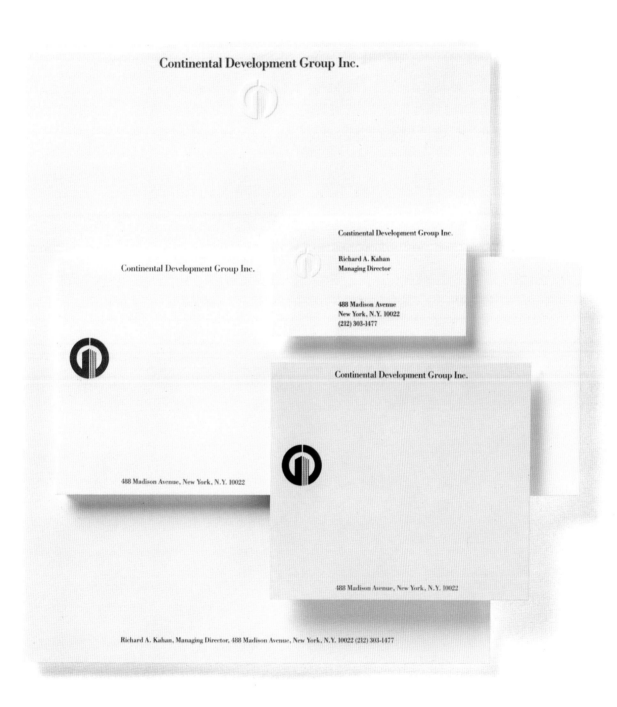

DESIGN FIRM Donovan and Green
ART DIRECTOR Michael Donovan
DESIGNER Dan Miller
CLIENT Continental Development Group, Inc.
PAPER/PRINTING Two colors on Protocol Writing Bright White

13

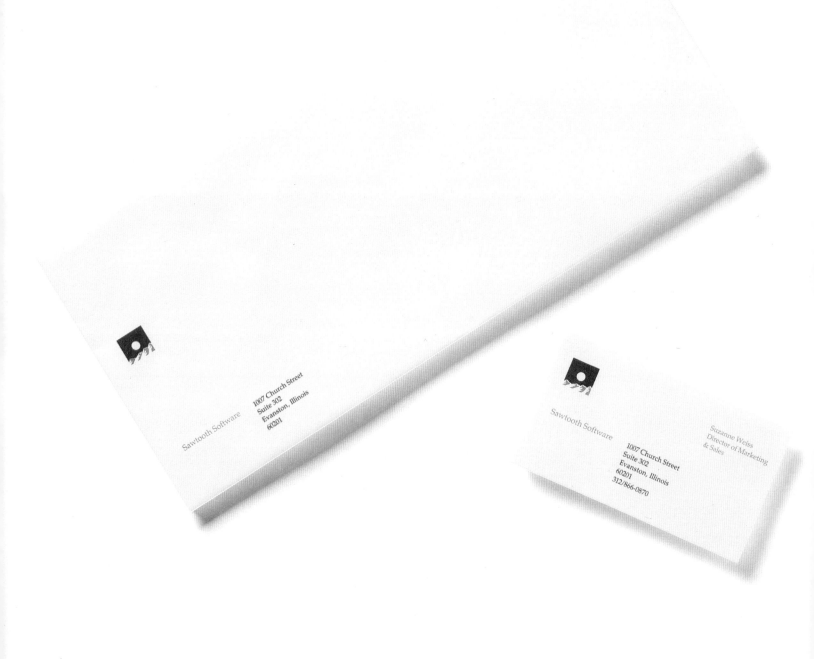

Sawtooth Software

1007 Church Street
Suite 302
Evanston, Illinois
60201

Sawtooth Software

Suzanne Weiss
Director of Marketing
& Sales

1007 Church Street
Suite 302
Evanston, Illinois
60201
312/866-0870

DESIGN FIRM	Michael Stanard, Inc.
ART DIRECTOR	Michael Stanard
DESIGNER	Ann Werner
CLIENT	Sawtooth Software
PAPER/PRINTING	Two colors on Crane's Crest

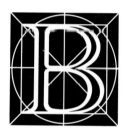

| | | | | | | |
|---|---|---|---|---|---|
| **DESIGN FIRM** | Design Center | **DESIGN FIRM** | Hornall Anderson Design Works | **DESIGN FIRM** | Tollner Design Group. |
| **ART DIRECTOR** | John Reger | **ART DIRECTOR** | Jack Anderson | **ART DIRECTOR** | Lisa Tollner |
| **DESIGNERS** | Kobe, D.W. Olson | **DESIGNERS** | Jack Anderson, Julie Tanagi- | **DESIGNER** | Karen Saucier |
| **CLIENT** | Arch Financial Systems | | Lock, Mary Hermes, | **ILLUSTRATOR** | Karen Saucier |
| | | | Heidi Hatlestad | **CLIENT** | Rabbit Copier and Service |
| | | **ILLUSTRATOR** | Brian O'Neill | | |
| | | **CLIENT** | Asymetrix Corporation | | |

DESIGN FIRM	J. Brelsford Design, Inc.	**DESIGN FIRM**	Design Center	**DESIGN FIRM**	Design Center
ART DIRECTOR	Jerry Brelsford	**ART DIRECTOR**	John Reger	**ART DIRECTOR**	John Reger
DESIGNER	Robert Whitmer	**DESIGNER**	C.S. Anderson	**DESIGNER**	Todd Spichke
CLIENT	Muehling Associates	**CLIENT**	Varitronics Systems Inc.	**CLIENT**	Bossardt Corporation

DESIGN FIRM	Hornall Anderson Design Works
ART DIRECTOR	Jack Anderson
DESIGNERS	Jack Anderson, Raymond Terada
CLIENT	James Frederick Housel
PAPER/PRINTING	Eight colors on Strathmore Writing

DESIGN FIRM	Laurel Bigley
ART DIRECTOR	Laurel Bigley
DESIGNER	Laurel Bigley
CLIENT	Adams Photography
PAPER/PRINTING	Letterhead–Three colors on Evergreen Kraft
	Envelopes–Wausau Vellum Opaque

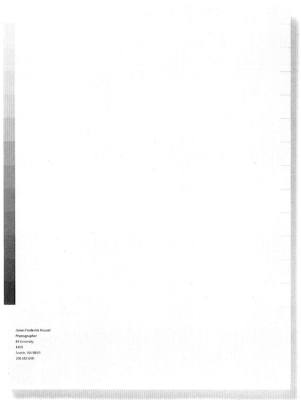

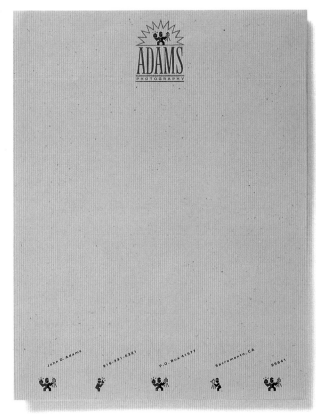

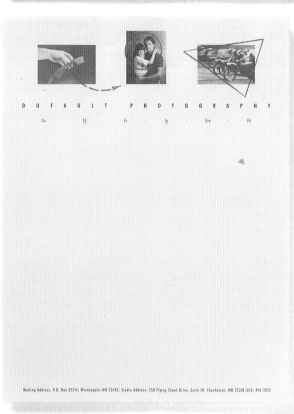

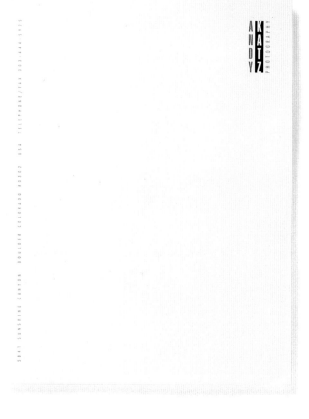

DESIGN FIRM	Steve Lundgren Graphic Design
ART DIRECTOR	Steve Lundgren
DESIGNER	Steve Lundgren
ILLUSTRATOR	Steve Lundgren
CLIENT	Kent DuFault
PAPER/PRINTING	Two colors on Neenah Classic Crest

DESIGN FIRM	Communication Arts Inc.
ART DIRECTOR	Richard Foy
DESIGNER	Hugh Enockson
CLIENT	Andy Katz Photography

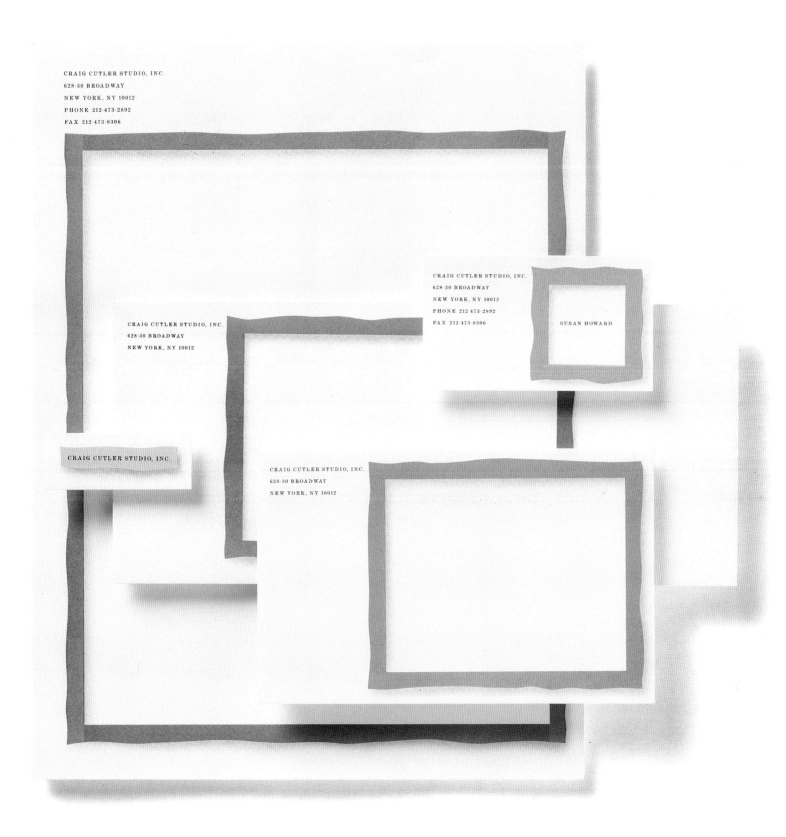

CRAIG CUTLER STUDIO, INC.
628-30 BROADWAY
NEW YORK, NY 10012
PHONE 212-473-2892
FAX 212-473-8306

CRAIG CUTLER STUDIO, INC.
628-30 BROADWAY
NEW YORK, NY 10012

CRAIG CUTLER STUDIO, INC.

CRAIG CUTLER STUDIO, INC.
628-30 BROADWAY
NEW YORK, NY 10012

CRAIG CUTLER STUDIO, INC.
628-30 BROADWAY
NEW YORK, NY 10012
PHONE 212-473-2892
FAX 212-473-8306

SUSAN HOWARD

DESIGN FIRM The Pushpin Group
DESIGNER Greg Simpson
CLIENT Craig Cutler Studio, Inc.

D'AGOSTINO IZZO QUIRK ARCHITECTS
432 COLUMBIA STREET CAMBRIDGE, MA 02141 TELEPHONE 617 547 3935 FAX 617 547 0990

DESIGN FIRM	Communication Arts, Inc.
ART DIRECTOR	Richard Foy
DESIGNER	David A. Shelton
CLIENT	DAIQ Architects
PAPER/PRINTING	Two colors on Strathmore Writing White Laid

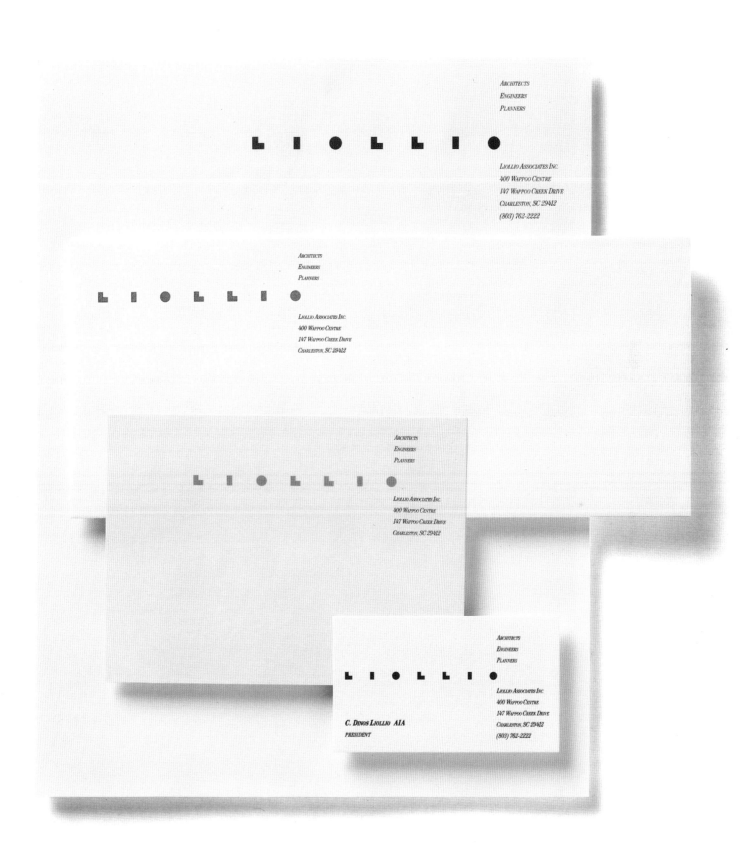

DESIGN FIRM	Rousso+Associates, Inc.
ART DIRECTOR	Steve Rousso
DESIGNER	Steve Rousso
CLIENT	Liollio Associates
PAPER/PRINTING	Two colors on Strathmore Writing

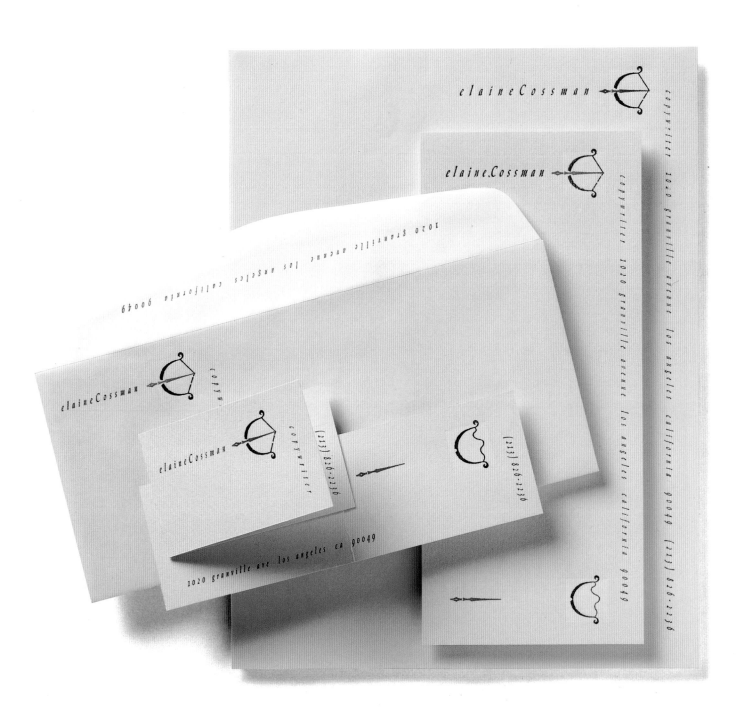

DESIGN FIRM	Margo Chase Design
ART DIRECTOR	Margo Chase
DESIGNER	Margo Chase
CLIENT	Elaine Crossman
PAPER/PRINTING	Three colors on Simpson Protocol

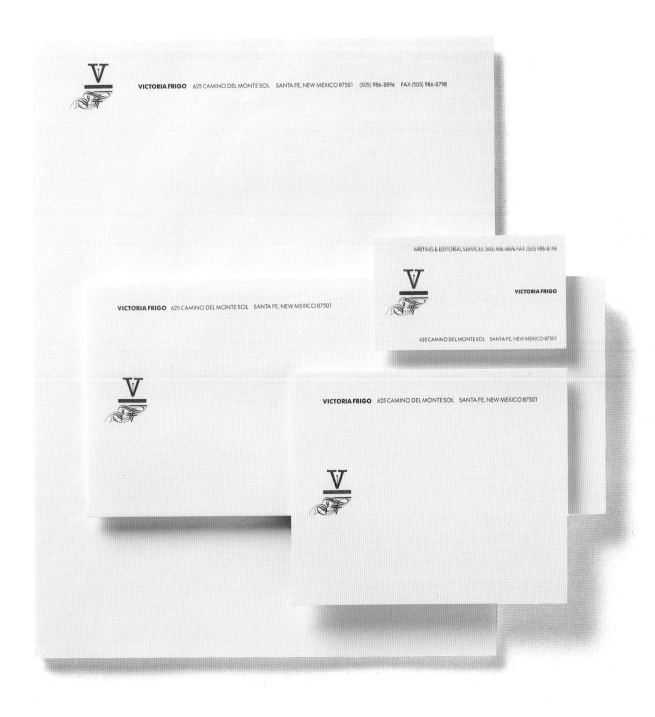

DESIGN FIRM Porter/Matjasich & Associates
ART DIRECTOR Allen Porter
DESIGNER Robert Rausch
ILLUSTRATOR Robert Rausch
CLIENT Victoria Frigo
PAPER/PRINTING Two colors on Strathmore Writing

Friendship One

Around the World
for Kids

Made possible by the
generous support of
United Airlines.

Friendship One

Around the World
for Kids

Friendship Foundation
(A Non-Profit Corporation)

c/o The Museum of Flight
9404 E. Marginal Way S.
Seattle, Washington 98108

Clay Lacy
President

Friendship One

Around the World
for Kids

c/o The Museum of Flight
9404 E. Marginal Way S.
Seattle, Washington 98108
(206) 764-5708
Fax # (206) 764-5707

Friendship Foundation
(A Non-Profit Corp.)

Friendship Foundation
(A Non-Profit Corporation)

c/o The Museum of Flight
9404 E. Marginal Way S.
Seattle, Washington 98108
(206) 764-5708
Fax # (206) 764-5707

DESIGN FIRM	Hornall Anderson Design Works
ART DIRECTOR	Jack Anderson
DESIGNERS	Jack Anderson, Julie Tanagi-Lock
CLIENT	Museum of Flight
PAPER/PRINTING	Four colors on Protocol Writing

FAMILY FEST

Columbia Point Boston, MA 02125

Family Fest, a family-oriented festival, benefits Ronald McDonald Children's Charities®, and is sponsored by
John F. Kennedy Library and Museum, McDonald's®, WMJX 106.7 FM, and WCVB-TV.

DESIGN FIRM	WCVB TV Design
ART DIRECTOR	Marc English
DESIGNER	Marc English
ILLUSTRATORS	Rebecka, Teena, Marc
CLIENT	JFK Library
PAPER/PRINTING	Five colors on Strathmore Writing

BusinessWeek
Office of the Publisher
1221 Avenue of the Americas
New York, N.Y. 10020

DESIGN FIRM Design Center
ART DIRECTOR John Reger
DESIGNER D.W. Olson
CLIENT Business Week Magazine

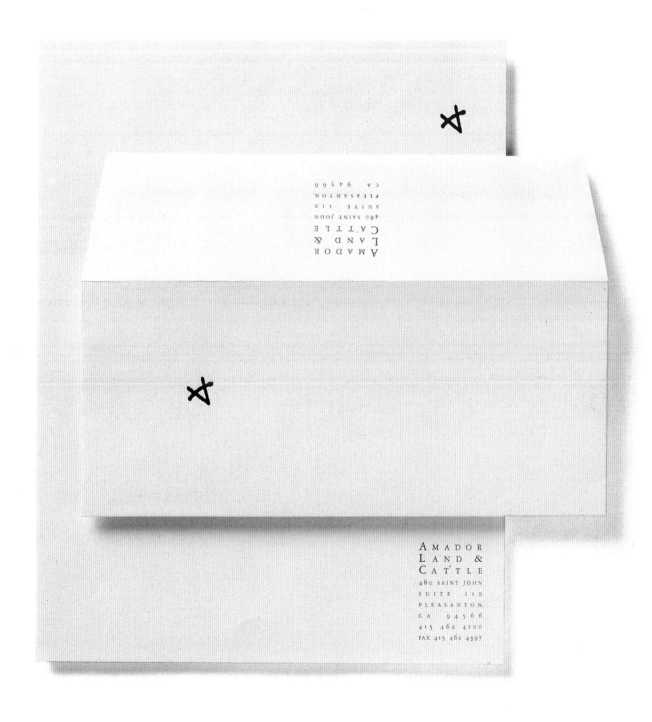

DESIGN FIRM Communication Arts Inc.
ART DIRECTOR Henry Beer
DESIGNER David A. Shelton
CLIENT Amador Land & Cattle
PAPER/PRINTING Two colors on Speckletone Ivory White Text

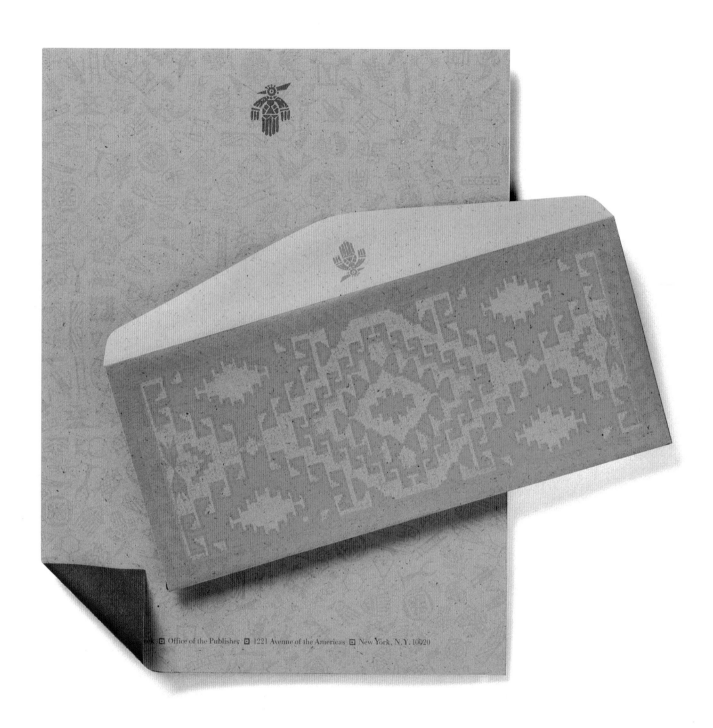

Office of the Publisher ▣ 1221 Avenue of the Americas ▣ New York, N.Y. 10020

DESIGN FIRM Design Center
ART DIRECTOR John Reger
DESIGNER D.W. Olson, Kobe
CLIENT Business Week Magazine
PAPER/PRINTING Two colors

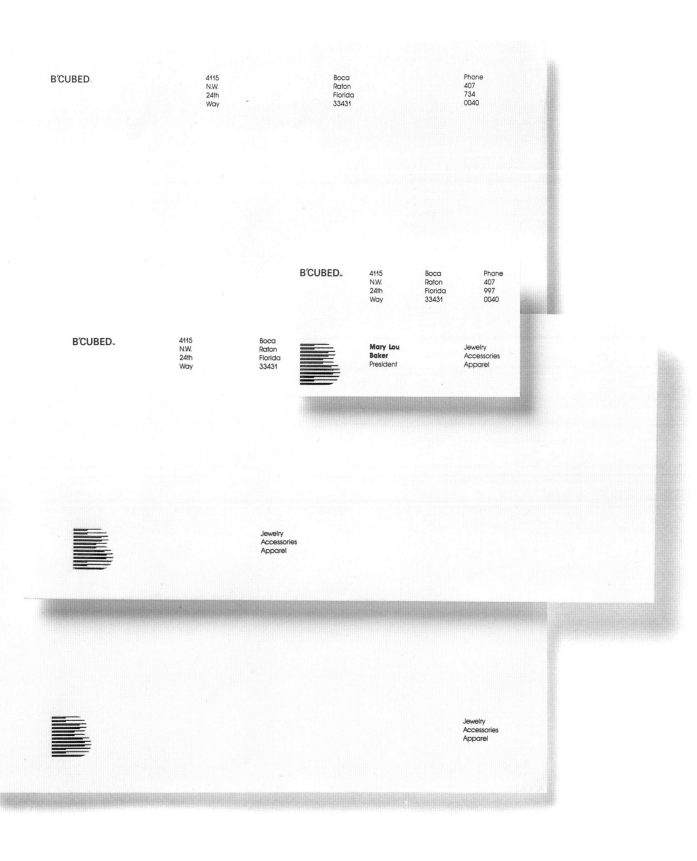

DESIGN FIRM	Creative Works
ART DIRECTOR	Bob Jahn
DESIGNER	Bob Jahn
ILLUSTRATOR	David Wright
CLIENT	B'Cubed Jewelry
PAPER/PRINTING	Two colors on Strathmore Writing

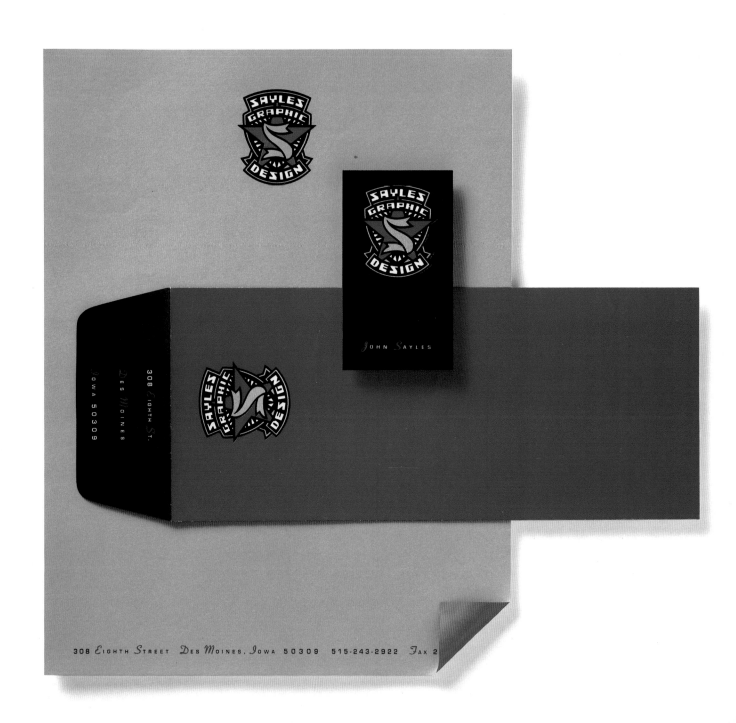

DESIGN FIRM	Sayles Graphic Design
ART DIRECTOR	John Sayles
DESIGNER	John Sayles
CLIENT	Sayles Graphic Design
PAPER/PRINTING	Three colors and foil on Neenah Classic Crest

ROWLAND AND ELEANOR BINGHAM MILLER

ROWLAND AND ELEANOR BINGHAM MILLER

3 Mockingbird Place
Louisville, Kentucky 40207
(502) 893-2262 (502) 587-6970

DESIGN FIRM McCord Graphic Design
ART DIRECTORS Walter McCord and Eleanor Miller
DESIGNER Walter McCord
ILLUSTRATIONS (ca. 1870) Courtesy Filson Club Archives
CLIENT Roland & Eleanor Bingham Miller
PAPER/PRINTING Four color process on Strathmore Alexandra Brilliant

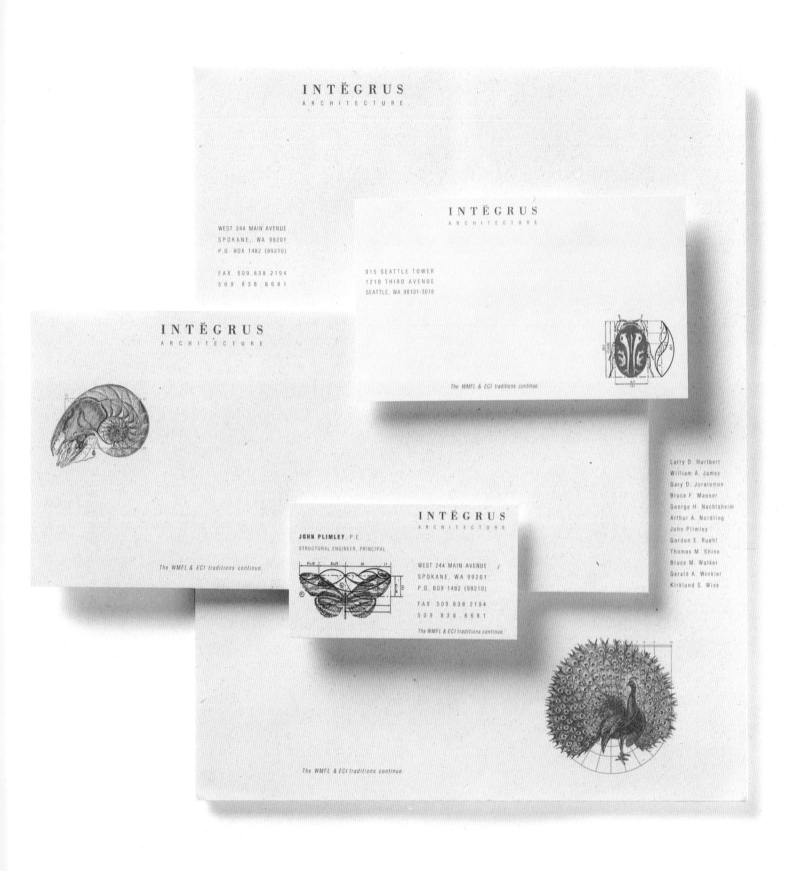

DESIGN FIRM	Hornall Anderson Design Works
ART DIRECTOR	John Hornall
DESIGNERS	John Hornall, Paula Cox, Brian O'Neill
CLIENT	Integrus
PAPER/PRINTING	Two colors on Neenah Environment

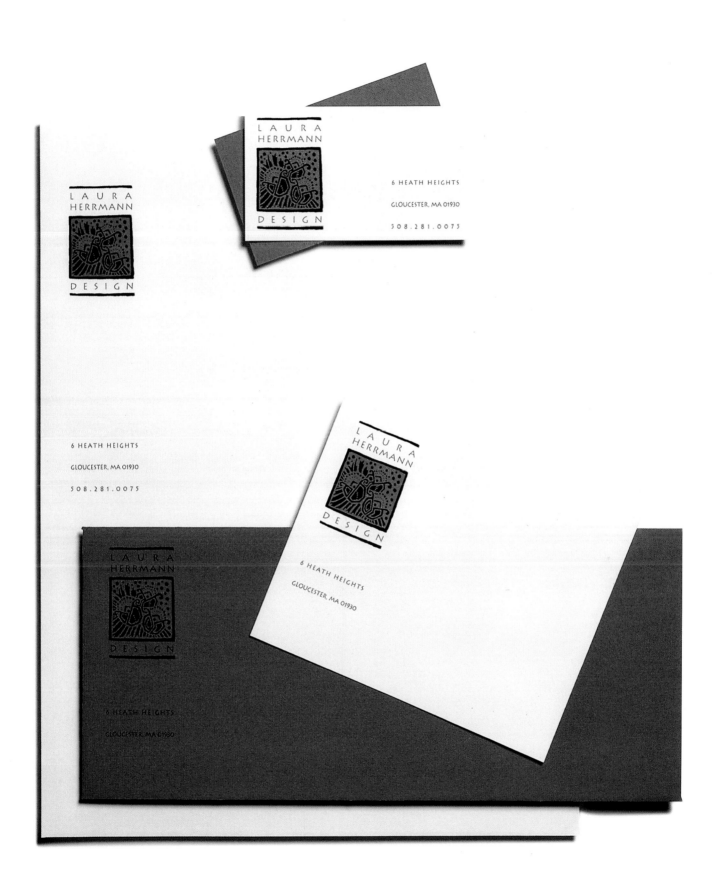

DESIGN FIRM	Laura Herrmann Design
ART DIRECTOR	Laura Herrmann
DESIGNER	Laura Herrmann
CLIENT	Laura Herrmann Design
PAPER/PRINTING	Classic Linen, Writing and Duplex

DESIGN FIRM	Handler Design Ltd.
ART DIRECTOR	Bruce Handler
DESIGNER	Bruce Handler
ILLUSTRATOR	Ray Ringston III
CLIENT	Martial Arts Institute of America
PAPER/PRINTING	Strathmore Bond

DESIGN FIRM	Image Group
ART DIRECTOR	David Zavala, Eric Sanchez
DESIGNER	David Zavala, Eric Sanchez
ILLUSTRATOR	David Zavala
CLIENT	Assistance Dog Institute
PAPER/PRINTING	Concept

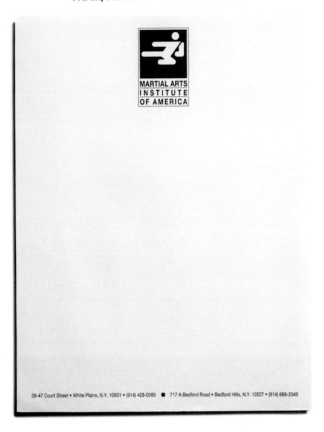

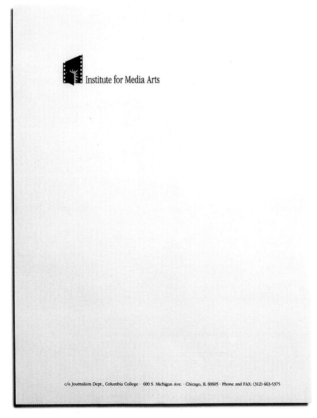

DESIGN FIRM	Jon Wells Associates
DESIGNER	Jon Wells
ILLUSTRATOR	Institute for Media Arts
CLIENT	Curtis Brightwater

DESIGN FIRM	Integrate Inc.
ART DIRECTOR	Stephen Quinn
DESIGNER	Darryl Levering
ILLUSTRATOR	Darryl Levering
CLIENT	Columbus Zoo

Community Partnership
of Santa Clara County

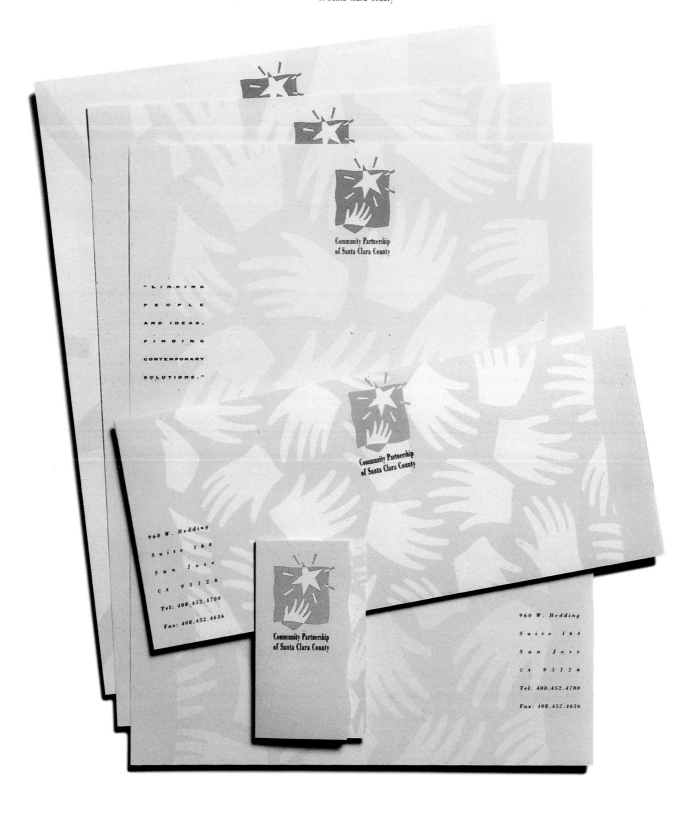

DESIGN FIRM Earl Gee Design
ART DIRECTOR Fani Chung
DESIGNER Fani Chung
ILLUSTRATOR Earl Geè, Fani Chung
CLIENT Community Partnership of Santa Clara County
PAPER/PRINTING Speckletone Cream text

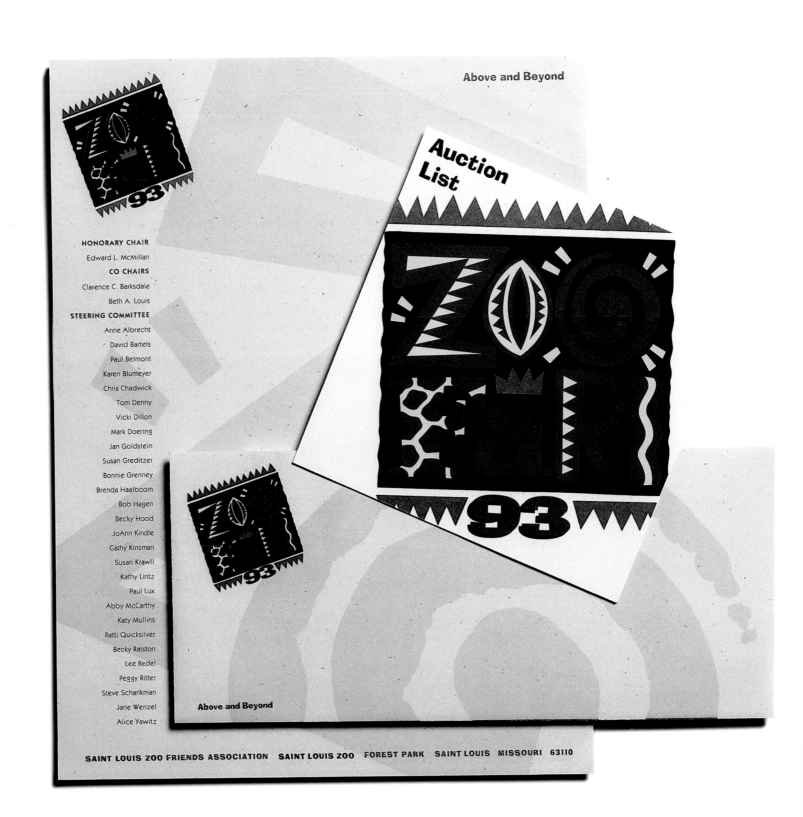

HONORARY CHAIR
Edward L. McMillan

CO CHAIRS
Clarence C. Barksdale
Beth A. Louis

STEERING COMMITTEE
Anne Albrecht
David Bartels
Paul Belmont
Karen Blumeyer
Chris Chadwick
Tom Denny
Vicki Dillon
Mark Doering
Jan Goldstein
Susan Greditzer
Bonnie Grenney
Brenda Haalboom
Bob Hagen
Becky Hood
JoAnn Kindle
Cathy Kinsman
Susan Krawll
Kathy Lintz
Paul Lux
Abby McCarthy
Katy Mullins
Patti Quicksilver
Becky Ralston
Lee Redel
Peggy Ritter
Steve Schankman
Jane Wenzel
Alice Yawitz

Above and Beyond

SAINT LOUIS ZOO FRIENDS ASSOCIATION SAINT LOUIS ZOO FOREST PARK SAINT LOUIS MISSOURI 63110

DESIGN FIRM	Bartels & Company
ART DIRECTOR	David Bartels
DESIGNER	Brian Barclay
ILLUSTRATOR	Brian Barclay
CLIENT	St. Louis Zoo/Zoofari '93

34

PITTSBURGH PUBLIC THEATER
ASSOCIATION

Allegheny Square
Pittsburgh, PA 15212-5349
412 323-8200 Ext. 207
Fax 412 323-8550

DESIGN FIRM	Adam, Filippo & Associates
ART DIRECTOR	Robert A. Adam
DESIGNER	Adam, Filippo & Associates
CLIENT	Pittsburgh Public Theater Association

DESIGN FIRM	O&J Design, Inc.
ART DIRECTOR	Andrzej J. Olejniczak
DESIGNER	Andrzej J. Olejniczak
CLIENT	Corporate Communication Group
PAPER/PRINTING	Starwhite Vicksburg/4 colors

DESIGN FIRM	Heart Graphic Design
ART DIRECTOR	Clark Most
DESIGNER	Joan Most
CLIENT	English Training Consultants
PAPER/PRINTING	Cottonwood/Evergreen

DESIGN FIRM	Shields Design
ART DIRECTOR	Charles Shields
DESIGNER	Charles Shields
CLIENT	The Ken Roberts Company/
	Four Star Books
PAPER/PRINTING	Neenah Classic Crest

DESIGN FIRM	The Design Associates
ART DIRECTOR	Victor Cheong
DESIGNER	Victor Cheong, Philip Sven
CLIENT	THS Productions
PAPER/PRINTING	Conqueror, foil stamp

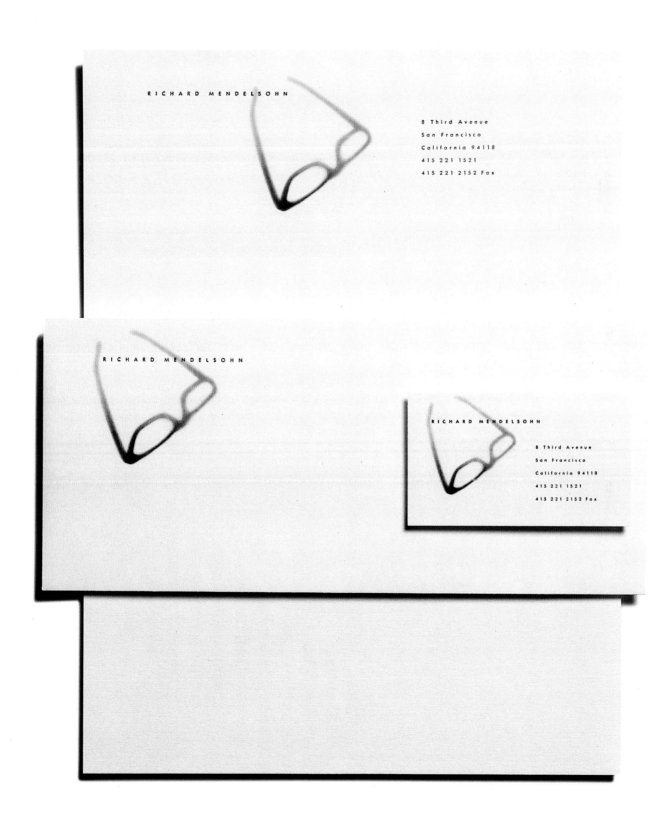

DESIGN FIRM	Debra Nichols Design
ART DIRECTOR	Debra Nichols
DESIGNER	Debra Nichols, Kelan Smith
ILLUSTRATOR	Mark Schroeder
CLIENT	Richard Mendelsohn

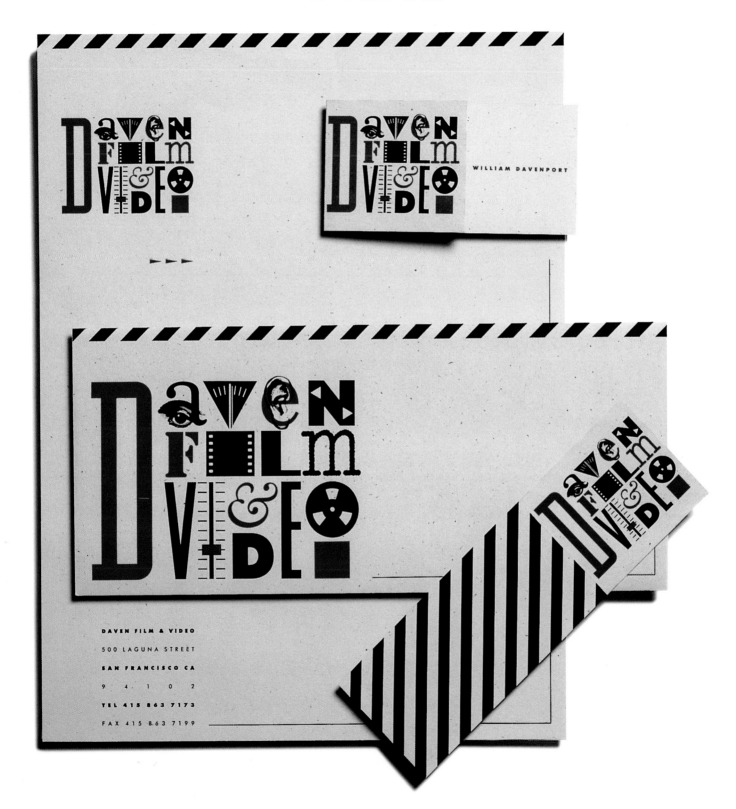

DESIGN FIRM Earl Gee Design
ART DIRECTOR Earl Gee
DESIGNER Earl Gee
ILLUSTRATOR Earl Gee
CLIENT Daven Film & Video
PAPER/PRINTING Speckletone Natural text

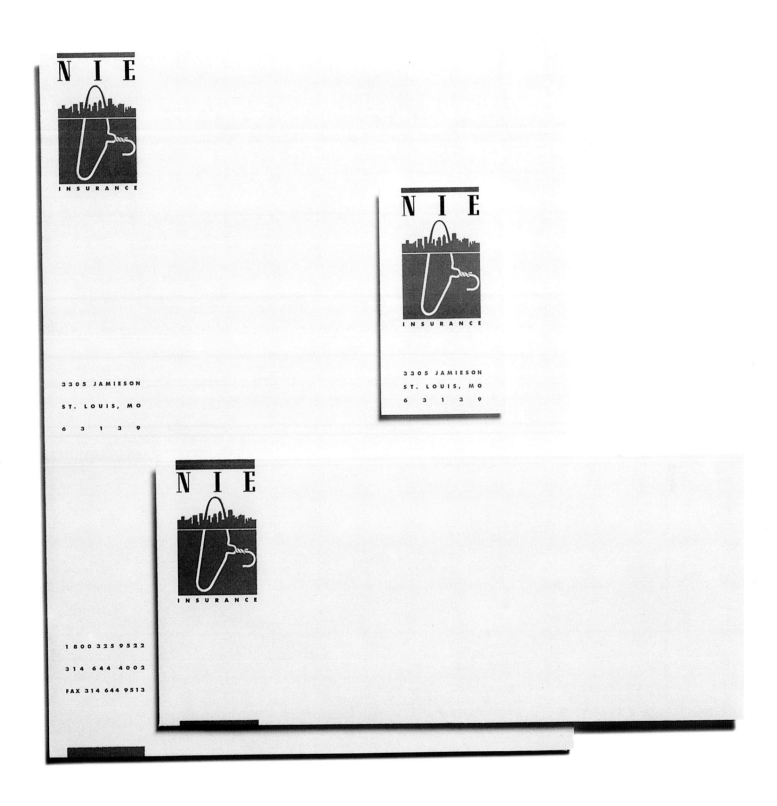

DESIGN FIRM	Bartels & Company, Inc.
ART DIRECTOR	David Bartels
DESIGNER	Aaron Segall
ILLUSTRATOR	Aaron Segall
CLIENT	NIE Insurance

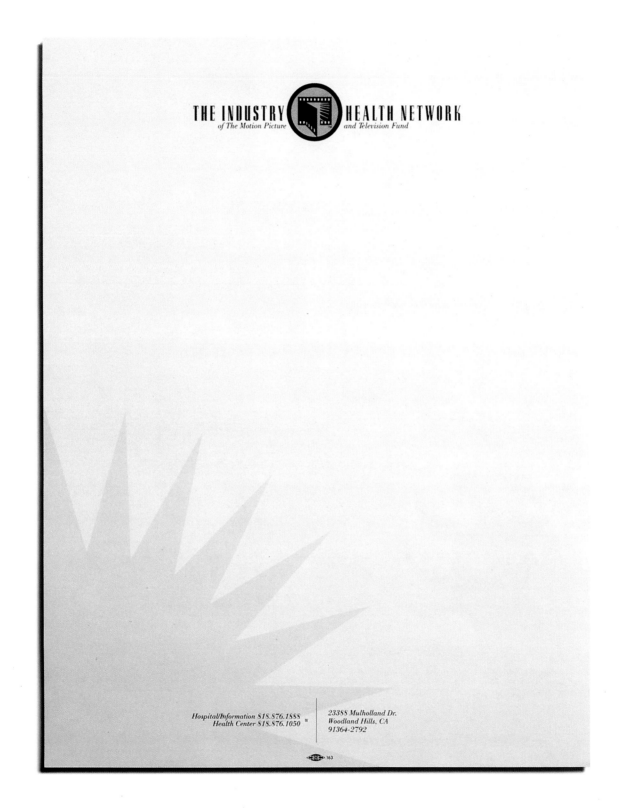

DESIGN FIRM	Vrontikis Design Office
ART DIRECTOR	Petrula Vrontikis
DESIGNER	Kim Sage
CLIENT	MPTF Industry Health Network
PAPER/PRINTING	Classic Crest Solar White

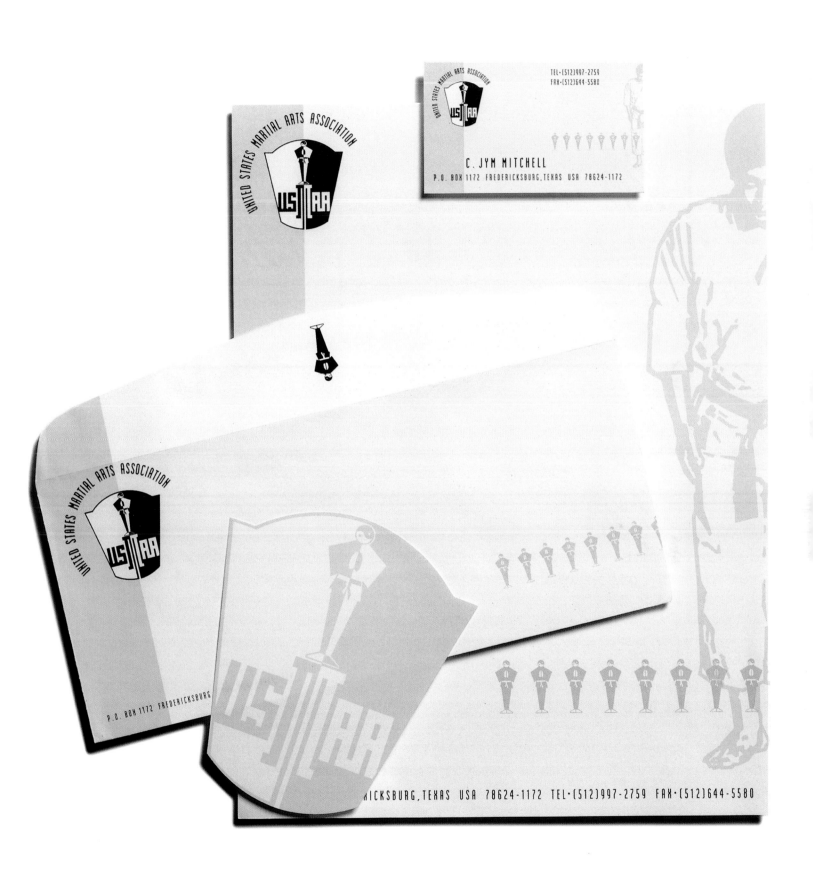

DESIGN FIRM	Romeo Empire Design
ART DIRECTOR	Vincent Romeo
DESIGNER	Vincent Romeo
ILLUSTRATOR	Vincent Romeo
CLIENT	United States Martial Arts Association
PAPER/PRINTING	Mohawk Superfine

Friends Of The Zoo

Friends of the
Washington Park Zoo

4001 S.W. Canyon Road
Portland, OR 97221-2799
(503) 226-1561
FAX (503) 226-6836

Friends Of The Zoo

Friends of the
Washington Park Zoo

4001 S.W. Canyon Road
Portland, OR 97221-2799
(503) 226-1561
FAX (503) 226-6836

Margie Mee Pate
Executive Director

"Caring Now for
the Future of Life"

Friends Of The Zoo

Friends of the
Washington Park Zoo

4001 S.W. Canyon Road
Portland, OR 97221-2799

"Caring Now for the Future of Life"

"Caring Now for the Future of Life"

DESIGN FIRM	Smith Group Communications
ART DIRECTOR	Gregg Frederickson
DESIGNER	Lena James
ILLUSTRATOR	Lena James
CLIENT	Friends of the Zoo
PAPER/PRINTING	Classic Crest

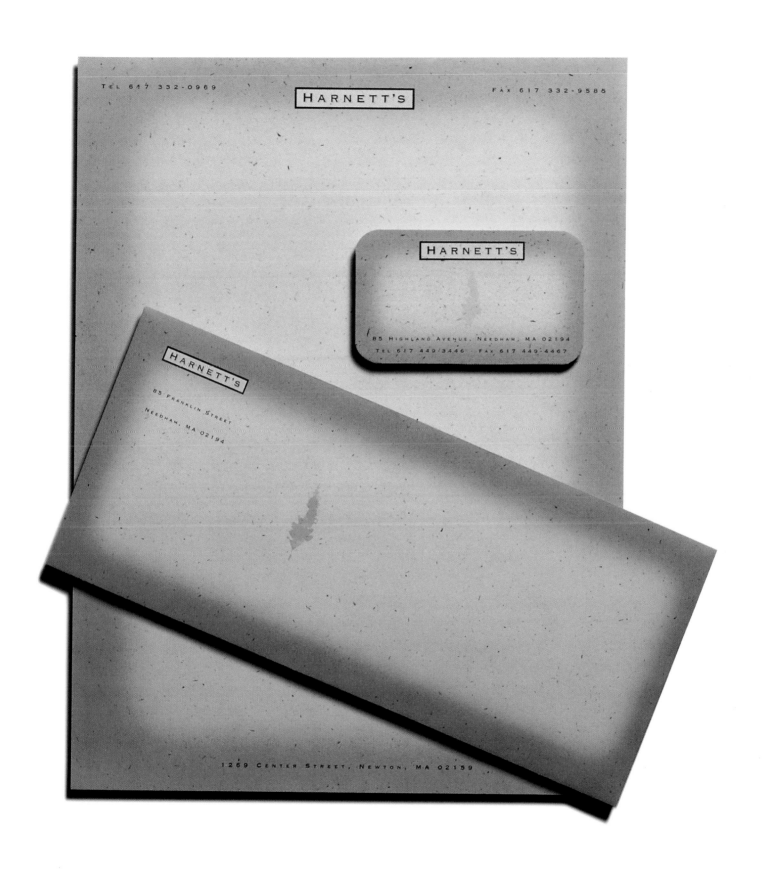

DESIGN FIRM Clifford Selbert Design
ART DIRECTOR Melanie Lowe
DESIGNER Melanie Lowe
CLIENT Harnett's
PAPER/PRINTING Champion Benefit

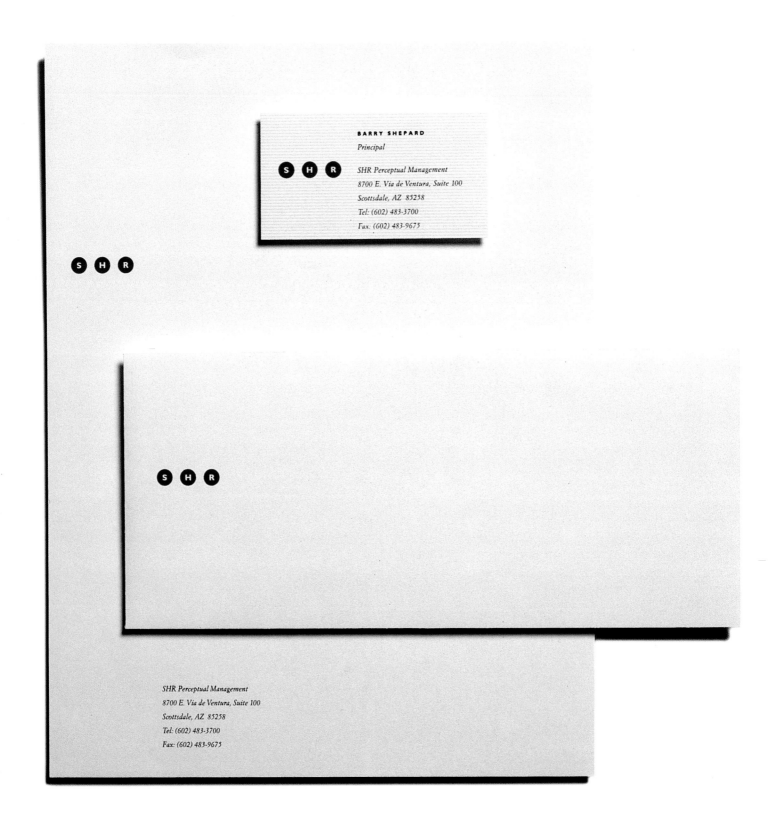

BARRY SHEPARD
Principal

SHR Perceptual Management
8700 E. Via de Ventura, Suite 100
Scottsdale, AZ 85258
Tel: (602) 483-3700
Fax: (602) 483-9675

SHR Perceptual Management
8700 E. Via de Ventura, Suite 100
Scottsdale, AZ 85258
Tel: (602) 483-3700
Fax: (602) 483-9675

DESIGN FIRM SHR Perceptual Management
ART DIRECTOR Barry Shepard
DESIGNER Nathan Joseph
CLIENT SHR Perceptual Management
PAPER/PRINTING Simpson Starwhite Vicksburg

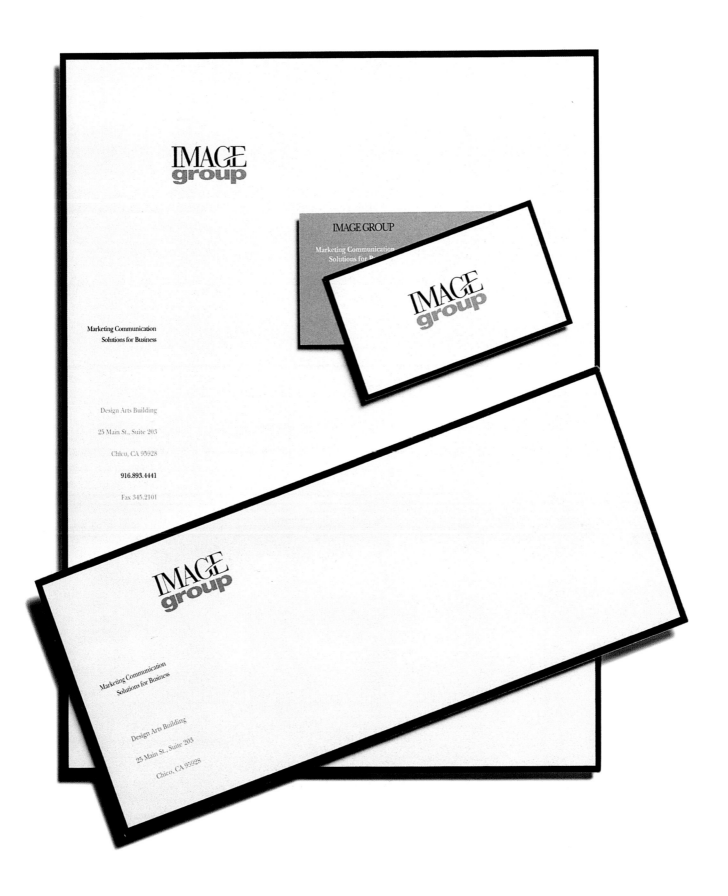

DESIGN FIRM	Image Group
ART DIRECTOR	Charles Osborn
DESIGNER	Charles Osborn, David Zavala, Eric Sanchez
CLIENT	Image Group
PAPER/PRINTING	Concept

TMCA

DESIGN & MARKETING
COMMUNICATIONS

P.O. Box 50216
Columbia • South Carolina
29250-0216 USA

Tim McKeever
President/Creative Director

TMCA

DESIGN & MARKETING
COMMUNICATIONS

TIM MCKEEVER COMMUNICATION ARTS, INC.
2231 Devine Street • Suite 304 • P.O. Box 50216
Columbia • South Carolina • 29250-0216 USA
☎ 803/256-3010 803/252-0424

TIM MCKEEVER COMMUNICATION ARTS, INC.
2231 Devine Street • Suite 304 • P.O. Box 50216
Columbia • South Carolina • 29250-0216 USA
☎ 803/256-3010 803/252-0424

DESIGN FIRM	TMCA, Inc.
ART DIRECTOR	Tim McKeever
DESIGNER	Tim McKeever
CLIENT	TMCA, Inc.
PAPER/PRINTING	Neenah Classic Crest, Avon Brilliant White, 4 colors

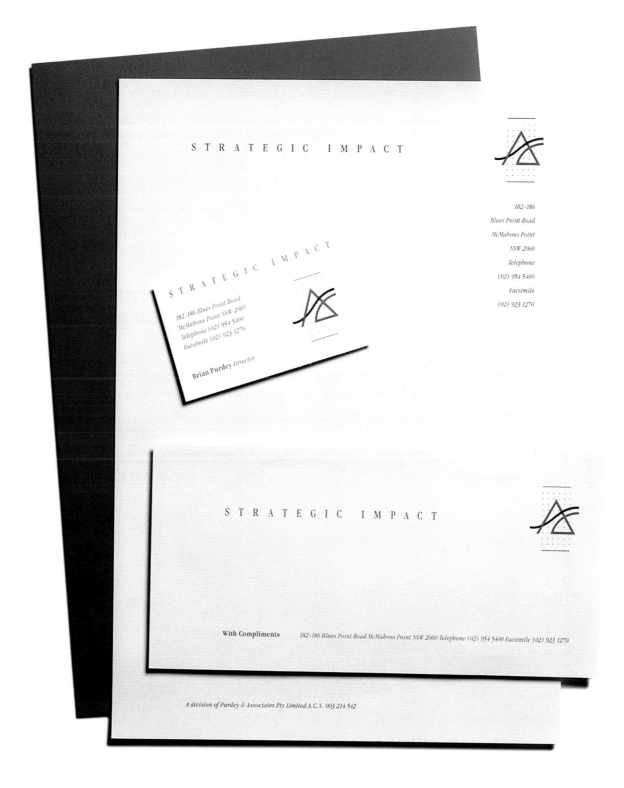

DESIGN FIRM Jenssen Design Pty. Limited
ART DIRECTOR David Jenssen
DESIGNER David Jenssen
ILLUSTRATOR Karen Lloyd-Jones
CLIENT Strategic Impact
PAPER/PRINTING Conservation White Laid

GATTORNA
STRATEGY

Gattorna Strategy
Consultants Pty Ltd
Inc in NSW
1 James Place North Sydney
NSW 2060 Australia
Tel: (02) 959 3899
Fax: (02) 959 3990

131 Rokeby Road
Subiaco
WA 6008 Australia
Tel: (09) 381 3580
Fax: (09) 382 2519

708C Swanson Road
Swanson
PO Box 83163 Edmonton
Auckland 8 New Zealand
Tel: (09) 833 9991
Fax: (09) 833 9992

33 South Montilla
San Clemente
CA 92672
USA
Tel: (714) 498 9440
Fax: (714) 492 1152

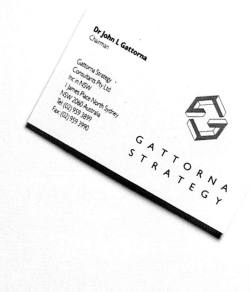

DESIGN FIRM	Jenssen Design Pty. Limited
ART DIRECTOR	David Jenssen
DESIGNER	David Jenssen
ILLUSTRATOR	David Jenssen, Yahyeh Abouloukme
CLIENT	Gattorna Strategy Consultants Pty. Ltd.
PAPER/PRINTING	Strathmore Writing, Bright White Laid

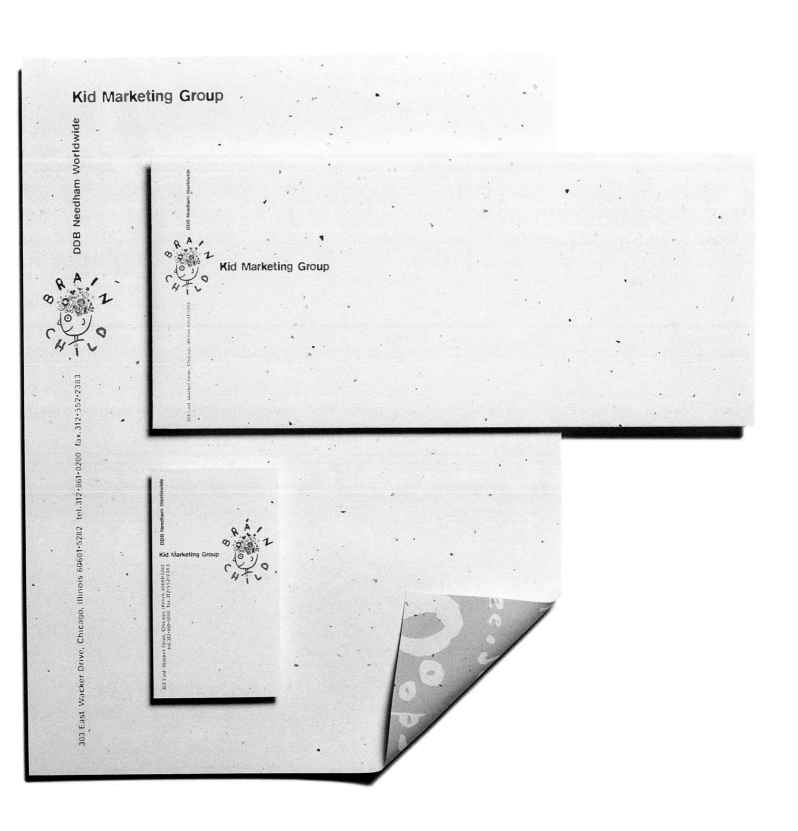

DESIGN FIRM	Segura Inc.
ART DIRECTOR	Carlos Segura
DESIGNER	Carlos Segura
ILLUSTRATOR	John Stepping
CLIENT	Brain Child
PAPER/PRINTING	Argus

DESIGN FIRM	The Weller Institute for the Cure of Design, Inc.	**DESIGN FIRM**	Schowalter² Design	**DESIGN FIRM**	Adam, Filippo & Associates
ART DIRECTOR	Don Weller	**ART DIRECTOR**	Toni Schowalter	**ART DIRECTOR**	Robert A. Adam
DESIGNER	Don Weller	**DESIGNER**	Ilene Price, Toni Schowalter	**DESIGNER**	Sharon L. Bretz, Barbara Peak Long
ILLUSTRATOR	Don Weller	**CLIENT**	Green Point Bank	**CLIENT**	Tuscarora Inc.
CLIENT	Western Exposure				

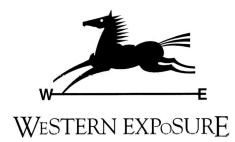

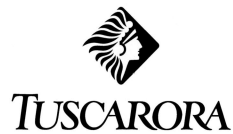

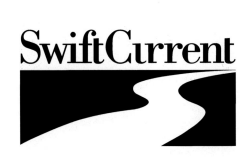

DESIGN FIRM	Palmquist & Palmquist Design	**DESIGN FIRM**	MacVicar Design & Communications	**DESIGN FIRM**	Schowalter² Design
ART DIRECTOR	Kurt & Denise Palmquist	**ART DIRECTOR**	John Vance	**ART DIRECTOR**	Toni Schowalter
DESIGNER	Kurt & Denise Palmquist	**DESIGNER**	William A. Gordon	**DESIGNER**	Ilene Price, Toni Schowalter
CLIENT	Swiftcurrent (film and video production company)	**CLIENT**	Newsletter Services, Inc.	**CLIENT**	Towers Perrin
PAPER/PRINTING	Quintessence Gloss Book				

DESIGN FIRM	Lambert Design Studio		**DESIGN FIRM**	Aslan Grafix		**DESIGN FIRM**	TW Design
ART DIRECTOR	Christie Lambert		**ART DIRECTOR**	Tracy Grubbs		**DESIGNER**	Jordan Patsios
DESIGNER	Joy Cathey		**DESIGNER**	Tracy Grubbs		**CLIENT**	MARCAM Corporation
CLIENT	Ideas & Solutions		**CLIENT**	Argadine Publishing			

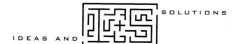 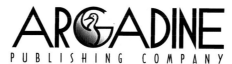

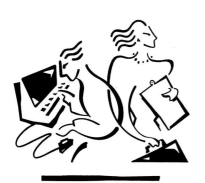

DESIGN FIRM	Riley Design Associates		**DESIGN FIRM**	Lambert Design Studio		**DESIGN FIRM**	Vaughn Wedeen Creative
ART DIRECTOR	Daniel Riley		**ART DIRECTOR**	Christie Lambert		**ART DIRECTOR**	Steve Wedeen
DESIGNER	Daniel Riley		**DESIGNER**	Christie Lambert, Joy Cathey		**DESIGNER**	Lisa Graff
ILLUSTRATOR	Daniel Riley		**ILLUSTRATOR**	Joy Cathey		**ILLUSTRATOR**	Lisa Graff
CLIENT	Hiring Resources		**CLIENT**	ProjectWorks		**COMPUTER PRODUCTION**	Chip Wyly
						CLIENT	Stratecom
						PAPER/PRINTING	Starwhite Vicksburg

51

113 Arthur Avenue

Des Moines, Iowa 50313

SHELLEY P. BRENTON
Director of Marketing

LOGO-MOTIVE Inc.

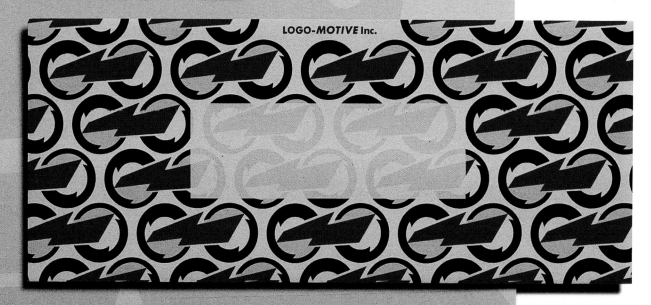

Ph. 515 · 243 · 4141 LOGO-MOTIVE Inc. FAX 515 · 243 · 7228

DESIGN FIRM Sayles Graphic Design
ART DIRECTOR John Sayles
DESIGNER John Sayles
ILLUSTRATOR John Sayles
CLIENT Logo-Motive
PAPER/PRINTING James River, Retreeve Gray, 2 colors

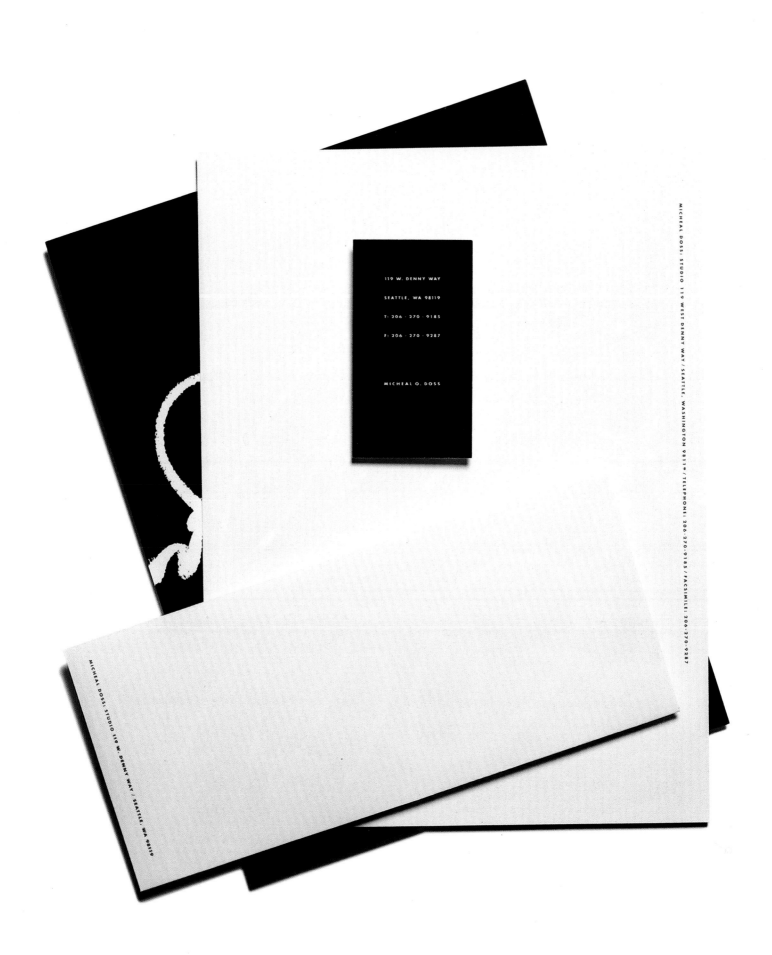

119 W. DENNY WAY

SEATTLE, WA 98119

T: 206 - 270 - 9185

F: 206 - 270 - 9287

MICHEAL O. DOSS

MICHEAL DOSS: STUDIO 119 WEST DENNY WAY / SEATTLE, WASHINGTON 98119 / TELEPHONE: 206-270-9185 / FACSIMILE: 206-270-9287

MICHEAL DOSS: STUDIO 119 W. DENNY WAY / SEATTLE, WA 98119

DESIGN FIRM	Hornall Anderson Design Works
ART DIRECTOR	Jack Anderson
DESIGNER	Jack Anderson
CLIENT	Micheal Doss

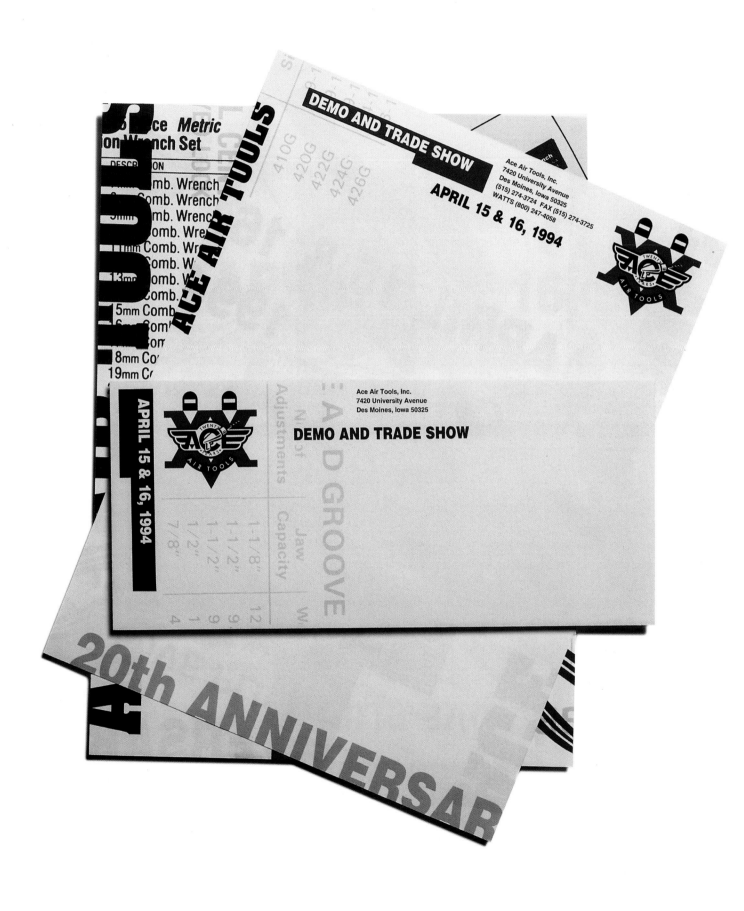

DESIGN FIRM	Sayles Graphic Design
ART DIRECTOR	John Sayles
DESIGNER	John Sayles
ILLUSTRATOR	John Sayles
CLIENT	Ace Air Tools
PAPER/PRINTING	James River, Graphika Vellum White, 2 colors

S T A R W A V E
C O R P O R A T I O N

S T A R W A V E
C O R P O R A T I O N

13810 S.E. EASTGATE WAY

SUITE 400

BELLEVUE, WA 98005

S T A R W A V E
C O R P O R A T I O N

RICHARD O'KEEFE

SENIOR SYSTEMS ENGINEER

206.957.2704

13810 S.E. EASTGATE WAY

SUITE 400

BELLEVUE, WA 98005

FAX 206.957.2009

RICHARDO@STARWAVE.COM

206.957.2000

FAX 206.957.2009

13810 S.E. EASTGATE WAY

SUITE 400

BELLEVUE, WA 98005

DESIGN FIRM Hornall Anderson Design Works

ART DIRECTOR Jack Anderson

DESIGNER Jack Anderson, David Bates, Lian Ng, Denise Weir

ILLUSTRATOR John Fretz

CLIENT Starwave Corporation

PAPER/PRINTING Neenah Classic Crest, embossed

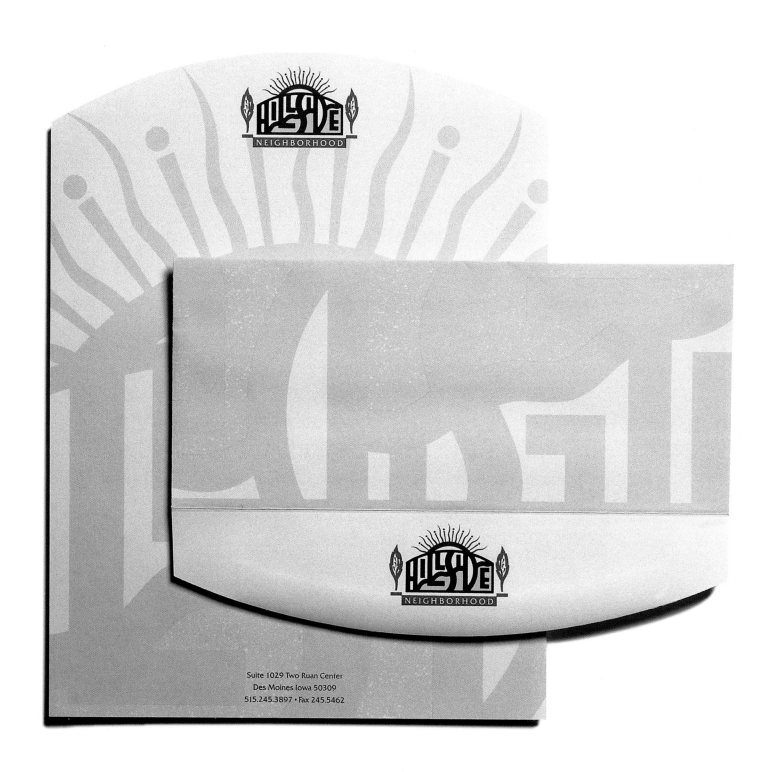

Suite 1029 Two Ruan Center
Des Moines Iowa 50309
515.245.3897 • Fax 245.5462

DESIGN FIRM Sayles Graphic Design
ART DIRECTOR John Sayles
DESIGNER John Sayles
ILLUSTRATOR John Sayles
CLIENT Hillside Neighborhood
PAPER/PRINTING James River, Vellum Gray, 2 colors

56

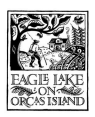

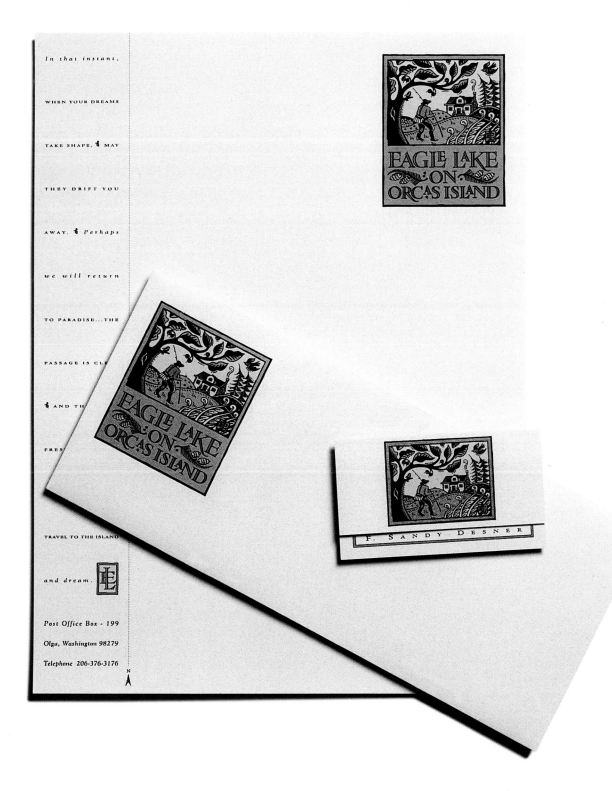

DESIGN FIRM Hornall Anderson Design Works
ART DIRECTOR Julia LaPine
DESIGNER Julia LaPine, Denise Weir
ILLUSTRATOR Julia LaPine
CLIENT Eagle Lake on Orcas Island
PAPER/PRINTING Simpson Environment Recycled

❶	DESIGN FIRM	Hornall Anderson Design Works, Inc.		❷	DESIGN FIRM	Richardson or Richardson
	ART DIRECTOR	Jack Anderson			ART DIRECTOR	Forrest Richardson
	DESIGNERS	Jack Anderson, David Bates, Julia LaPine, Mary Hermes			DESIGNER	Neill Fox
	ILLUSTRATOR	Yutaka Sasaki			ILLUSTRATOR	Neill Fox
	CLIENT	Travel Services of America			CLIENT	Wilderness Products, Inc.

❸	DESIGN FIRM	Barry Power Graphic Design		❹	DESIGN FIRM	Ad Dimension II, Inc.
	ART DIRECTOR	Barry Power			DESIGNERS	Barbara Larson, Karen Maxwell, Robert Bynder
	DESIGNER	Barry Power			CLIENT	Ad Dimension II, Inc.
	CLIENT	Barry Power				

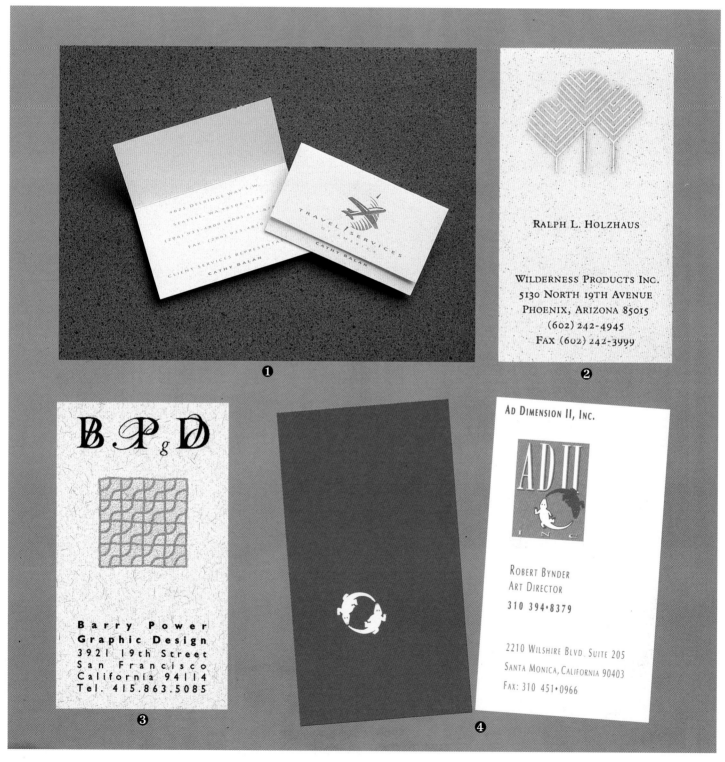

❶	DESIGN FIRM	Champ/Cotter	❷	DESIGN FIRM	Rochelle Seltzer Design
	DESIGNER	Heather Camp		ART DIRECTOR	Rochelle Seltzer
	CLIENT	Peter Moore & Associates		DESIGNER	Minnie Cho
				CLIENT	Vanesa Pliura Photography

❸	DESIGN FIRM	RJB Studio, Inc.	❹	DESIGN FIRM	Mervil Paylor Design
	ART DIRECTOR	Robert J. Bussey		DESIGNER	Mervil M. Paylor
	DESIGNER	Robert J. Bussey		CLIENT	Mervil Paylor Design
	CLIENT	Thomas Lowe Photography			

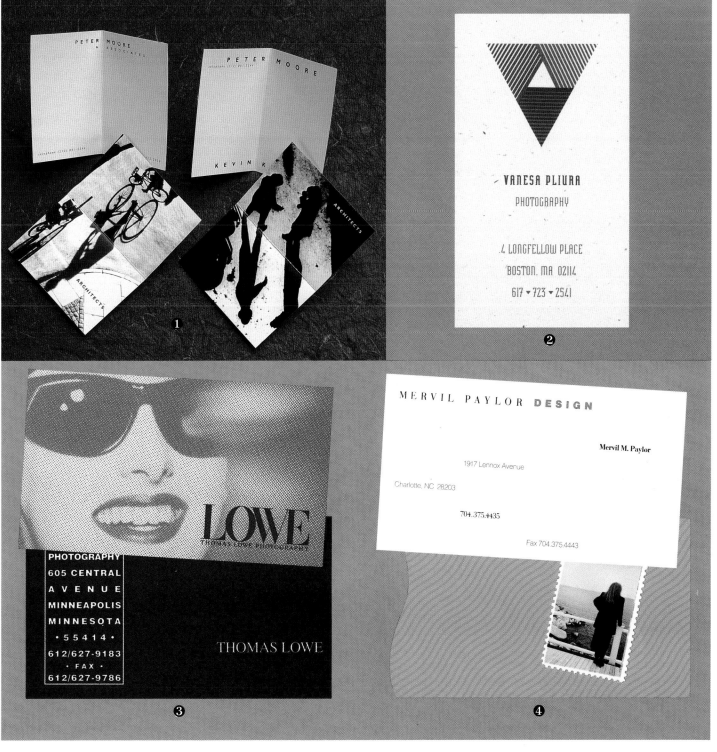

❶	**❷**	**❸**	**❹**
DESIGN FIRM	**DESIGN FIRM**	**DESIGN FIRM**	**DESIGN FIRM**
Siebert Design	Glazer Graphics	Integrate Inc.	Tharp Did It
Associates	**ART DIRECTOR**	**ART DIRECTOR**	**DESIGNERS**
ART DIRECTOR	Nancy Glazer	Stephen E. Quinn	Rick Tharp & Jean
Lori Siebert	**DESIGNER**	**DESIGNERS**	Mogannam
DESIGNERS	Nancy Glazer	Dan Shust, Stephen	**CLIENT**
Lori Siebert, David	**CLIENT**	Quinn	Invoke Software
Carroll	Glazer Graphics	**ILLUSTRATOR**	
CLIENT		Dan Shust	
Porter Printing		**CLIENT**	
		The Boulevard	
		Brochetterie	

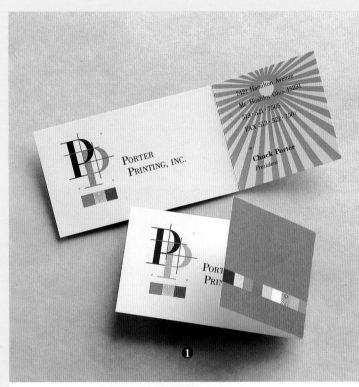

❶

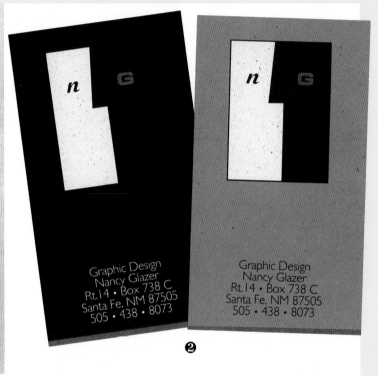

❷

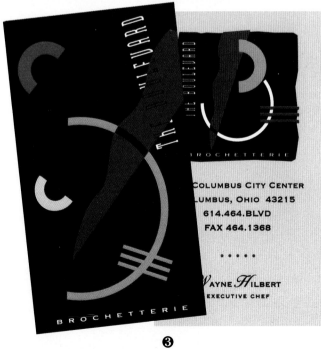

❸

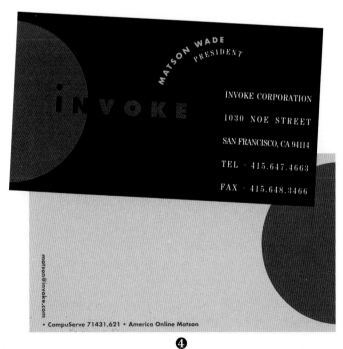

❹

❶
DESIGN FIRM
Lorna Stovall
Design
ART DIRECTOR
Lorna Stovall
DESIGNER
Lorna Stovall
CLIENT
Machine Head

❷
DESIGN FIRM
Lima Design
ART DIRECTORS
Mary Kliene,
Lisa McKenna
DESIGNER
M.J. Blanchette
CLIENT
Lima Design

❸
DESIGN FIRM
Garfinkle Design
ART DIRECTOR
Nina Garfinkle
DESIGNER
Nina Garfinkle
CLIENT
Garfinkle Design

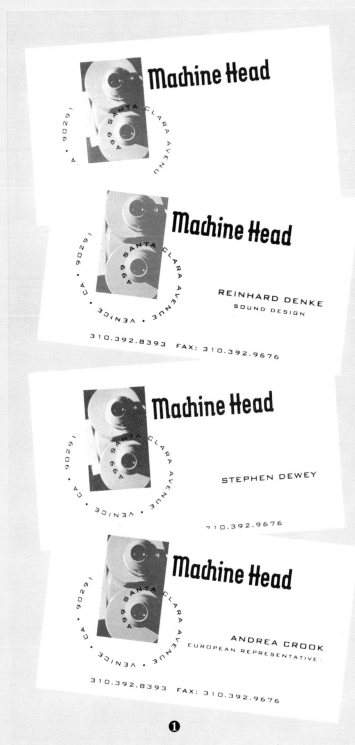

❶

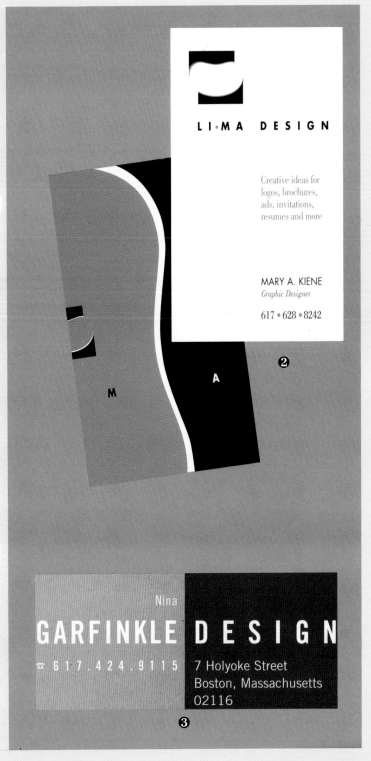

❷

❸

❶	❷	❸	❹	❺	❻
DESIGN FIRM	**DESIGN FIRM**	**DESIGN FIRM**	**DESIGN FIRM**	**DESIGN FIRM**	**DESIGN FIRM**
Ben & Jerry's Art Department	Ben & Jerry's Art Department	Ben & Jerry's Art Department	Ben & Jerry's Art Department	Ben & Jerry's Art Department	Ben & Jerry's Art Department
ART DIRECTOR	**ART DIRECTOR**	**ART DIRECTOR**	**ART DIRECTOR**	**ART DIRECTOR**	**ART DIRECTOR**
Lyn Severance	Lyn Severance	Lyn Severance	Lyn Severance	Lyn Severance	Lyn Severance
DESIGNER	**DESIGNER**	**DESIGNER**	**DESIGNER**	**DESIGNER**	**DESIGNER**
Lyn Severance	Melissa Salengo	Sarah Lee Terrat	Lyn Severance	Lyn Severance	Lyn Severance
ILLUSTRATOR	**ILLUSTRATOR**	**ILLUSTRATOR**	**ILLUSTRATOR**	**ILLUSTRATOR**	**ILLUSTRATOR**
Melissa Salengo	Melissa Salengo	Edgar Stewart	Melissa Salengo	Melissa Salengo	Catherine Dinsmore
CLIENT	**CLIENT**	**CLIENT**	**CLIENT**	**CLIENT**	**CLIENT**
Ben & Jerry's Homemade, Inc.	Ben & Jerry's Homemade, Inc.	Ben & Jerry's Homemade, Inc.	Ben & Jerry's Homemade, Inc.	Ben & Jerry's Homemade, Inc.	Ben & Jerry's Homemade, Inc.

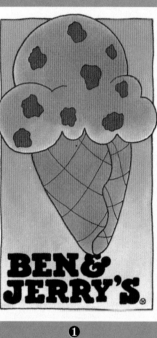

❶

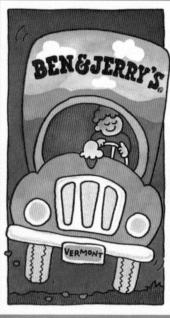

❷

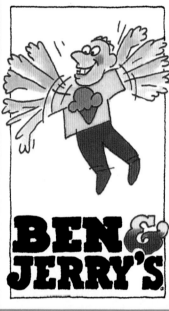

❸

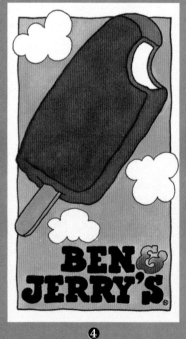

❹

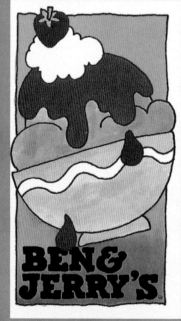

❺

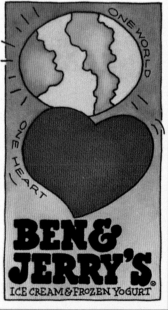

❻

❶	❷	❸	❹
DESIGN FIRM	**DESIGN FIRM**	**DESIGN FIRM**	**DESIGN FIRM**
Eilts Anderson Tracy	Richardson or Richardson	Eilts Anderson Tracy	Morla Design
ART DIRECTOR	**ART DIRECTORS**	**ART DIRECTORS**	**CLIENT**
Patrice Eilts	Forrest Richardson, Debi Young Mees	Patrice Eilts, Jan Tracy	Mitra Tyree
DESIGNER	**DESIGNERS**	**DESIGNERS**	
Patrice Eilts	Debi Young Mees, Neill Fox	Patrice Eilts, Jan Tracy	
ILLUSTRATOR	**CLIENT**	**CLIENT**	
Patrice Eilts	Darcy Paper Co., Inc.	Eilts Anderson Tracy Design	
CLIENT			
Michael Weaver			

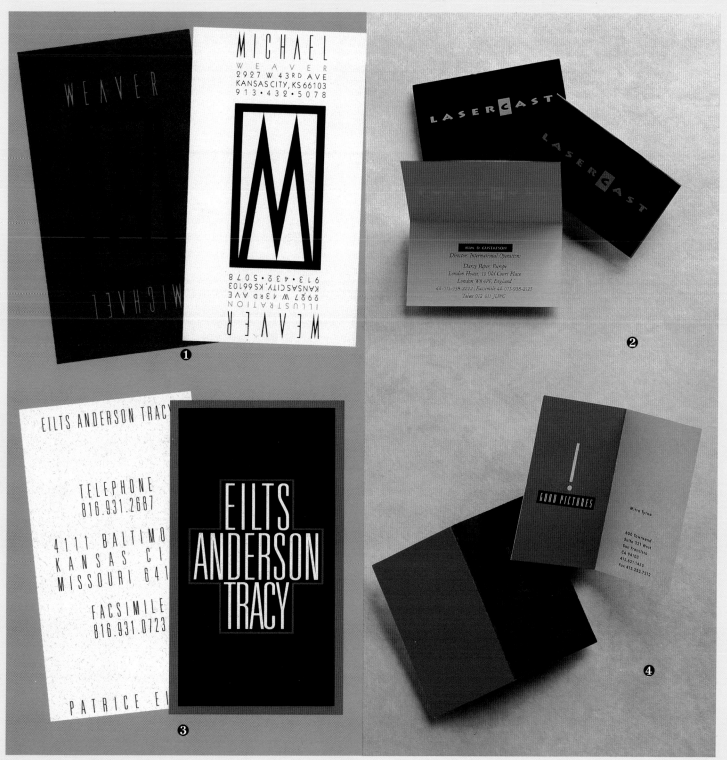

❷ **DESIGN FIRM** Eymont Kin-Yee
Hulett Pty. Ltd
ART DIRECTOR Anna Eymont
DESIGNER Anna Eymont
CLIENT Discware Computers

❸ **DESIGN FIRM** Champ/Cotter
DESIGNER Heather Champ
CLIENT Claire Champ

❶ **DESIGN FIRM** Hornall Anderson
Design Works, Inc.
ART DIRECTOR Jack Anderson
DESIGNERS Jack Anderson,
Heidi Hatlestad
CLIENT Six Sigma

❹ **DESIGN FIRM** Siebert Design Associates
ART DIRECTOR Lori Siebert
DESIGNER Barb Raymond
CLIENT Wyatt Design Associates

❺ **DESIGN FIRM** Tharp Did It
DESIGNER Rick Tharp
ILLUSTRATOR Kim Tomlinson
CLIENT The Dandy Candy Man

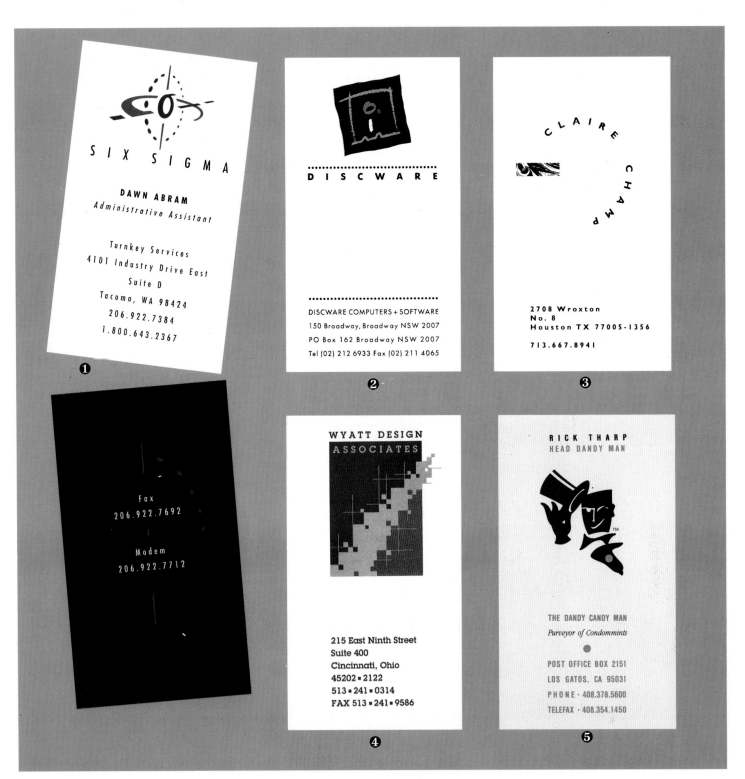

❶	**DESIGN FIRM**	ICONS
	ART DIRECTOR	Glenn Scott Johnson
	DESIGNER	Glenn Scott Johnson
	ILLUSTRATOR	Glenn Scott Johnson
	CLIENT	ICONS

❷	**DESIGN FIRM**	Design Group Cook
	ART DIRECTOR	Ken Cook
	DESIGNER	Ken Cook
	CLIENT	Pat Edwards
		Photography

❸	**DESIGN FIRM**	Michael Stanard Inc.
	ART DIRECTOR	Lisa Fingerhut
	DESIGNER	Michael Stanard
	CLIENT	Denise Stanard

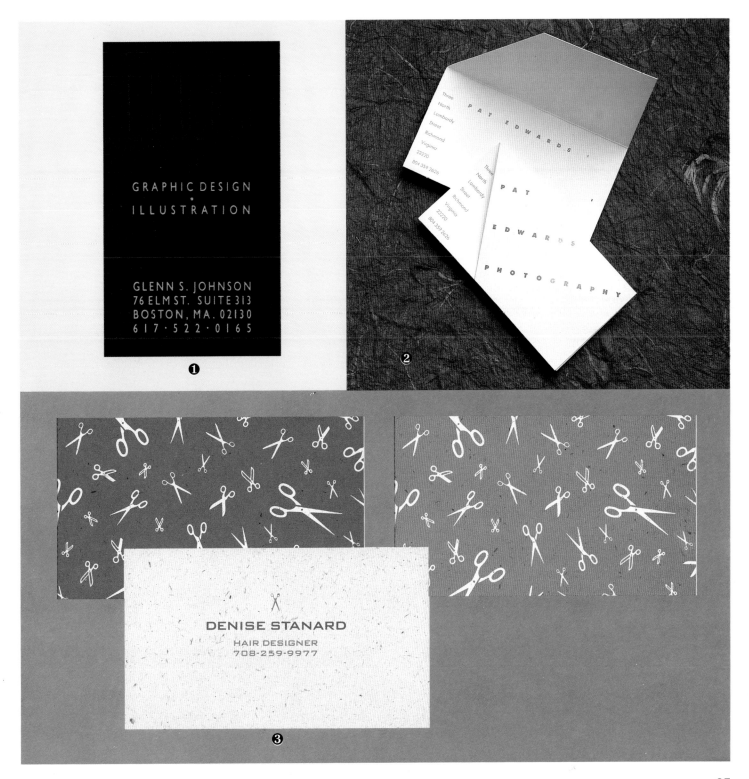

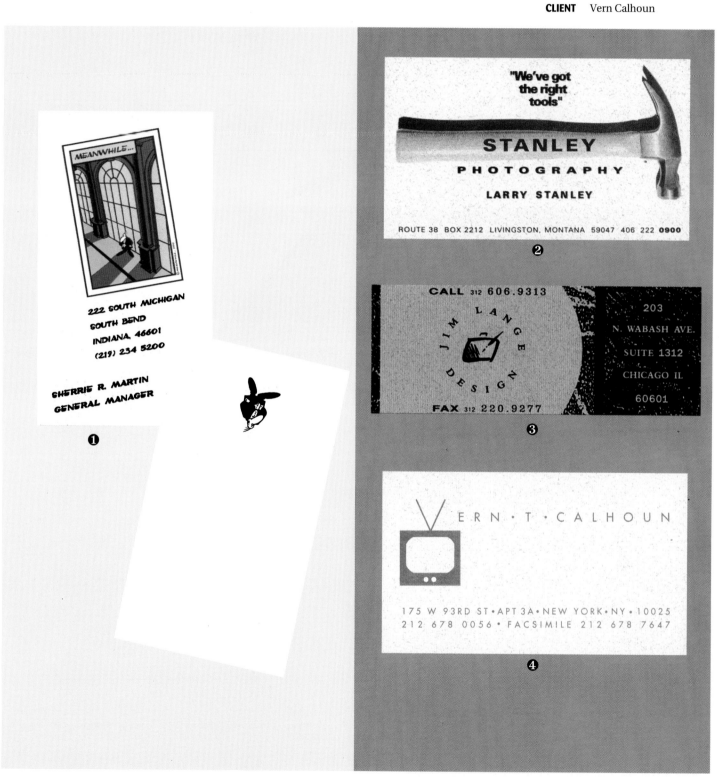

❶	**DESIGN FIRM**	Alex Shear & Associates
	ART DIRECTOR	Andrew Shear
	DESIGNER	Andrew Shear
	ILLUSTRATOR	Andrew Shear
	CLIENT	Andrew Shear

❷	**DESIGN FIRM**	Seman Design Group
	ART DIRECTOR	Richard M. Seman
	DESIGNER	Richard M. Seman
	ILLUSTRATOR	Doug Freeman
	CLIENT	Cynthia Thomassey

❸	**DESIGN FIRM**	Christine Haberstock
	ART DIRECTOR	Christine Haberstock
	DESIGNER	Christine Haberstock
	ILLUSTRATOR	Christine Haberstock
	CLIENT	Shooting Star

❹	**DESIGN FIRM**	Joseph Dieter Visual Communications
	ART DIRECTOR	Joseph M. Dieter, Jr.
	DESIGNER	Joesph M. Dieter, Jr.
	ILLUSTRATOR	Joesph M. Dieter, Jr.
	CLIENT	Joel Katz

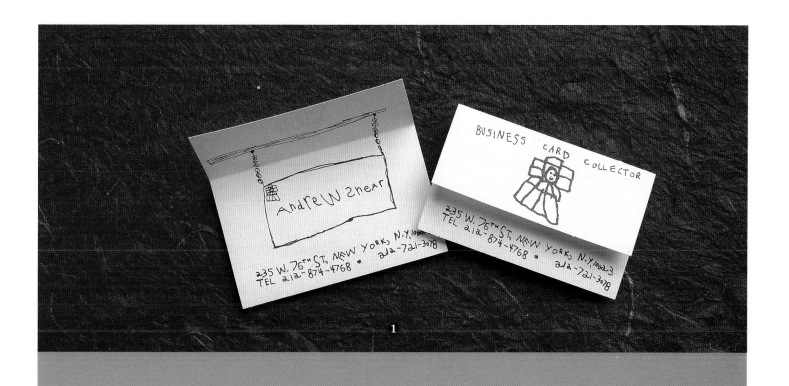

1

❷

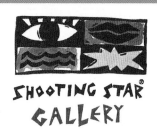

❸

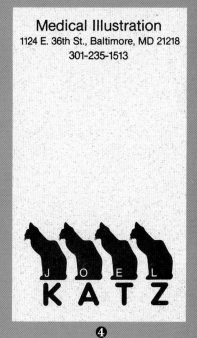

❹

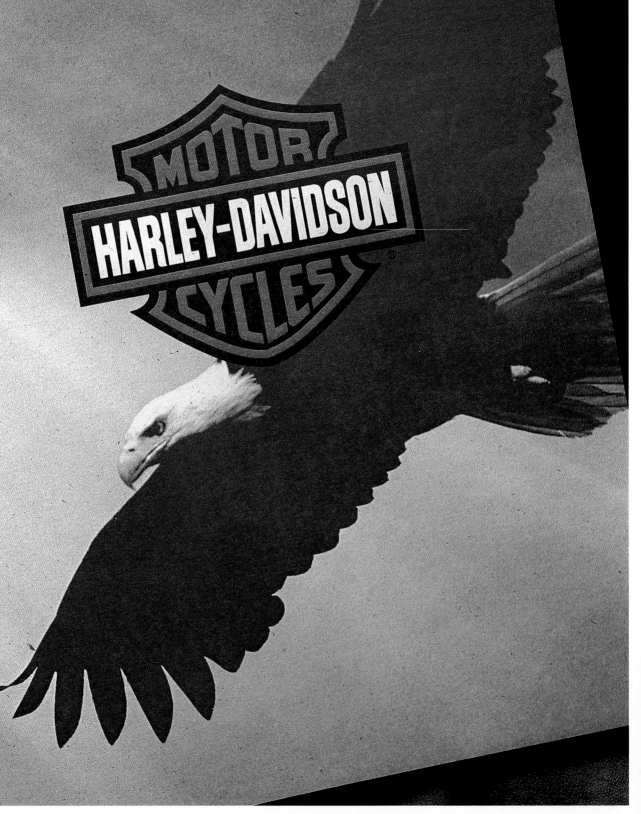

HARLEY-DAVIDSON®
GLOBAL COMMUNICATIONS
GUIDELINES

What the Harley–Davidson brand name represents crosses all social and political boundaries on the globe. To help the people who work for and with the company preserve, protect, and perpetuate the unmistakable sound of Harley–Davidson's corporate voice, Siegel & Gale created a spirited global communications guide-book—translated into the language of every country where the motorcycles are sold. By codifying the mystique of Harley–Davidson, Siegel & Gale was able to help the keepers of brand—the dealers, licensees, and communicators—maintain the Harley design philosophies in all visual presentations.

Siegel & Gale created corporate voice programs for BankOne, NationsBank, and PNC Bank among others. The fundamental personality of each financial institution is illuminated by corporate personality statements that are as unique and different as each bank.

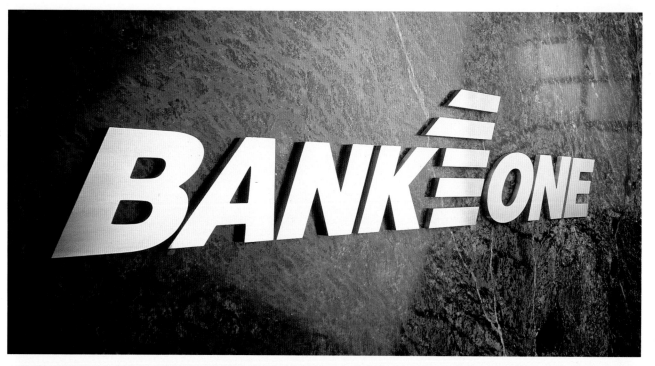

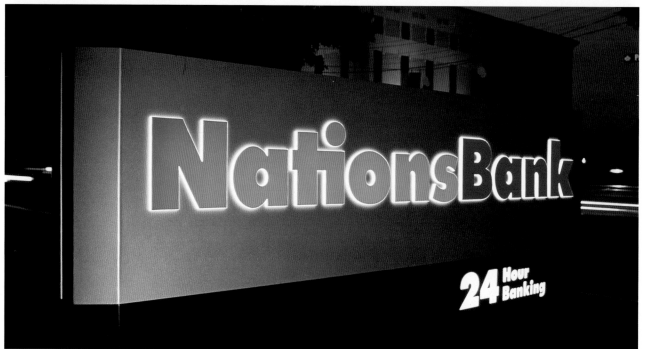

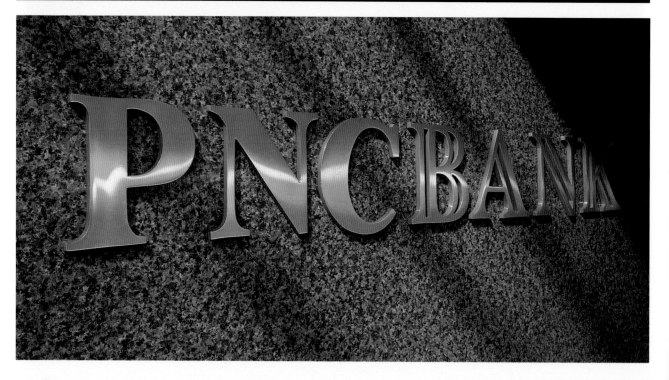

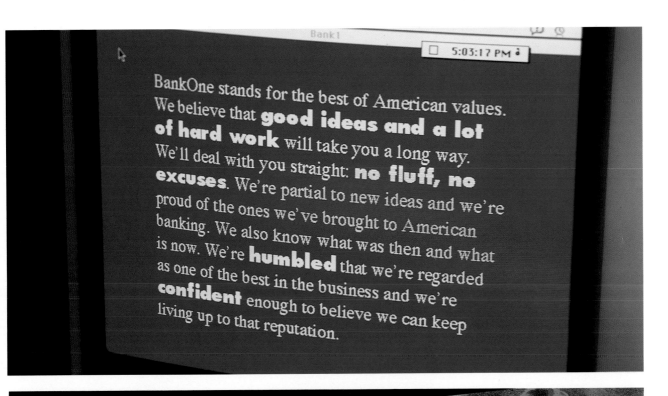

Bank1 5:03:17 PM

BankOne stands for the best of American values. We believe that **good ideas and a lot of hard work** will take you a long way. We'll deal with you straight: **no fluff, no excuses**. We're partial to new ideas and we're proud of the ones we've brought to American banking. We also know what was then and what is now. We're **humbled** that we're regarded as one of the best in the business and we're **confident** enough to believe we can keep living up to that reputation.

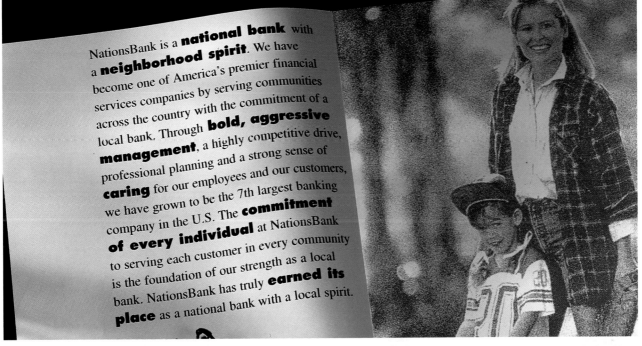

NationsBank is a **national bank** with a **neighborhood spirit**. We have become one of America's premier financial services companies by serving communities across the country with the commitment of a local bank. Through **bold, aggressive management**, a highly competitive drive, professional planning and a strong sense of **caring** for our employees and our customers, we have grown to be the 7th largest banking company in the U.S. The **commitment of every individual** at NationsBank to serving each customer in every community is the foundation of our strength as a local bank. NationsBank has truly **earned its place** as a national bank with a local spirit.

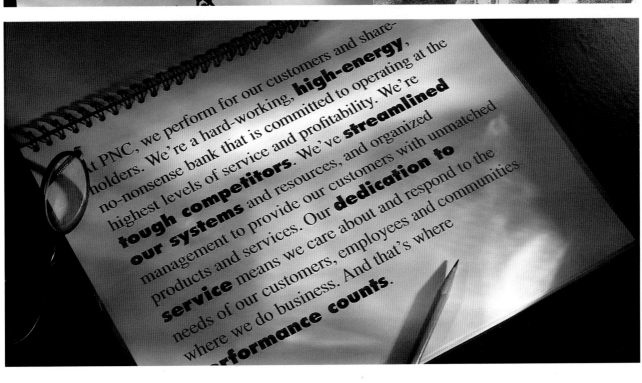

At PNC, we perform for our customers and share-holders. We're a hard-working, **high-energy**, no-nonsense bank that is committed to operating at the highest levels of service and profitability. We're **tough competitors**. We've **streamlined our systems** and resources, and organized management to provide our customers with unmatched products and services. Our **dedication to service** means we care about and respond to the needs of our customers, employees and communities where we do business. And that's where **performance counts**.

71

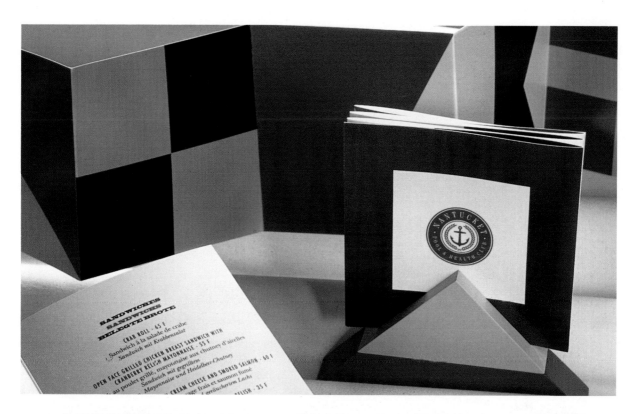

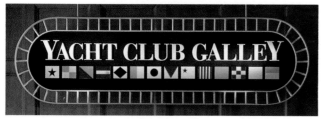

Clockwise from above

DESIGN FIRM	David Carter Design
ART DIRECTOR	Lori B. Wilson
DESIGNER	Lori B. Wilson
ILLUSTRATOR	Ashley Barron
CLIENT	Euro Disney Newport Bay Club
PAPER/PRINTING	Four colors

DESIGN FIRM	David Carter Design
ART DIRECTOR	David Carter Design
DESIGNER	Randall Hill
ILLUSTRATOR	Randall Hill
CLIENT	Hyatt Regency, La Jolla, California
PAPER/PRINTING	Two colors

DESIGN FIRM	David Carter Design
ART DIRECTOR	Ashley Barron
DESIGNER	Cynthia Waldman
CLIENT	Disneyworld Yacht Club
PAPER/PRINTING	Five colors

Facing page

DESIGN FIRM	David Carter Design
ART DIRECTOR	Kevin Prejean
DESIGNER	Kevin Prejean
ILLUSTRATOR	Kevin Prejean
CLIENT	Grand Hyatt, Bangkok
PAPER/PRINTING	Three colors

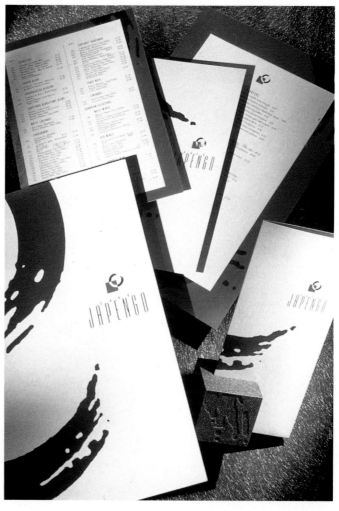

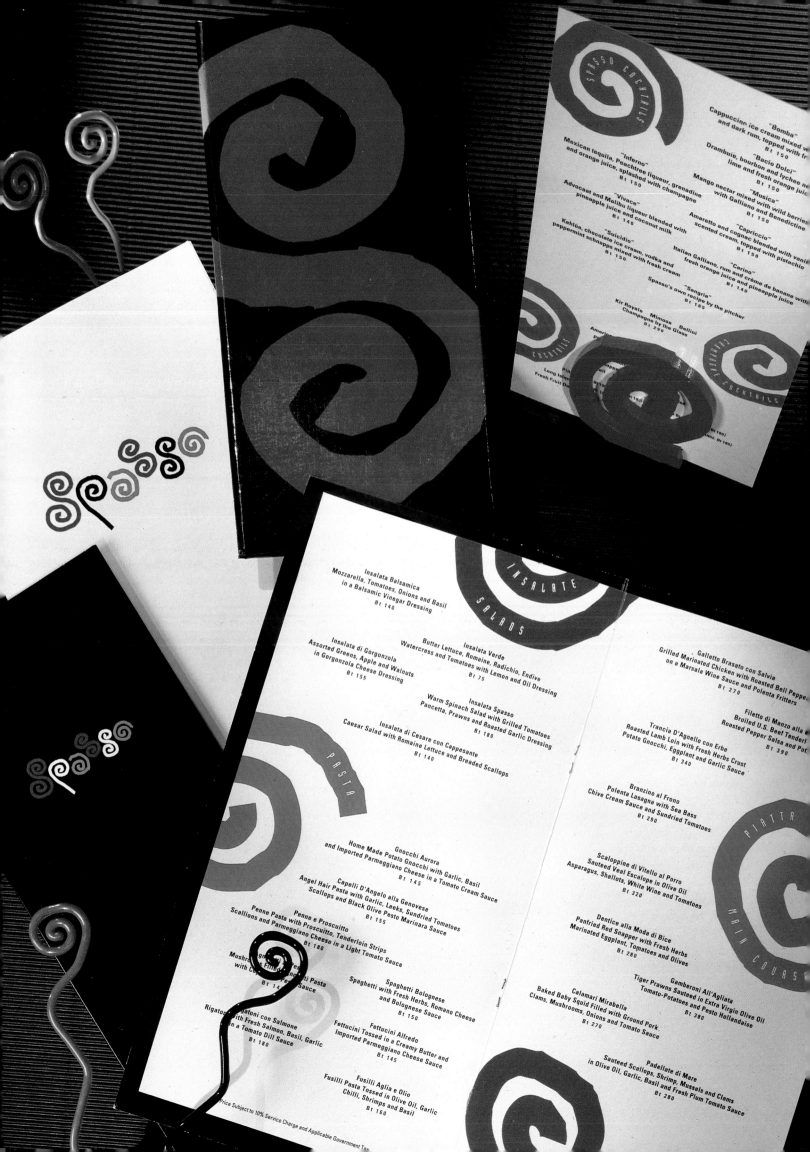

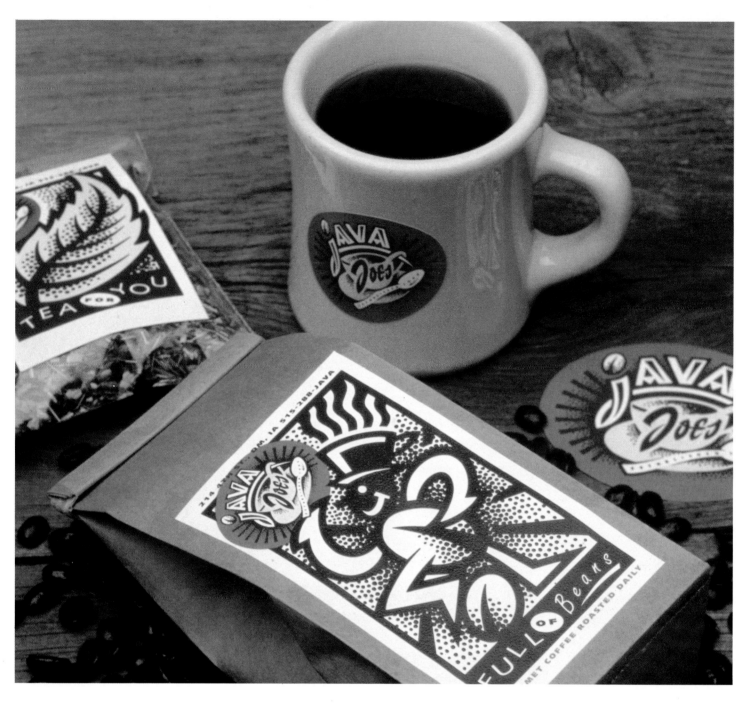

DESIGN FIRM	Sayles Graphic Design	
ART DIRECTOR	John Sayles	
DESIGNER	John Sayles	
ILLUSTRATOR	John Sayles	
CLIENT	Cyndy Coppola	
PAPER/PRINTING	Two colors	
DESIGN FIRM	Paper Shrine	
ART DIRECTOR	Paul Dean	
DESIGNER	Paul Dean	
CLIENT	Livingston's, I Presume	
PAPER/PRINTING	One color	

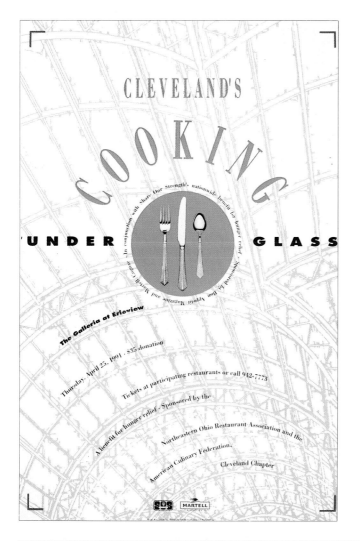

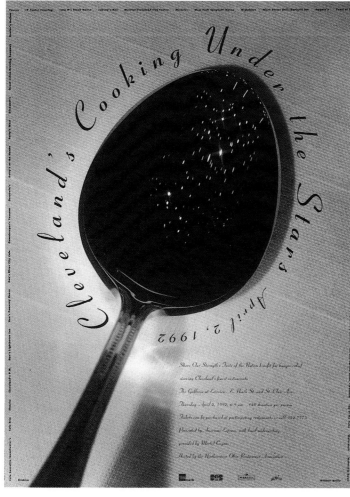

Clockwise from above left

DESIGN FIRM	Watt Roop & Co
ART DIRECTOR	S. Jeffrey Prugh
DESIGNER	S. Jeffrey Prugh
PHOTOGRAPHER	Don Synder
CLIENT	Northeastern Ohio Restaurant Association
PAPER/PRINTING	Four colors

DESIGN FIRM	Watt Roop & Co.
ART DIRECTOR	S. Jeffrey Prugh
DESIGNER	S. Jeffrey Prugh
PHOTOGRAPHER	Beth Segal
CLIENT	Northeastern Ohio Restaurant Association
PAPER/PRINTING	Five colors

DESIGN FIRM	Watt Roop & Co.
ART DIRECTOR	Gregory Oznowich
DESIGNER	Gregory Oznowich
PHOTOGRAPHER	Don Synder
CLIENT	Northeastern Ohio Restaurant Association
PAPER/PRINTING	Four colors

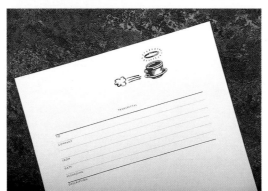

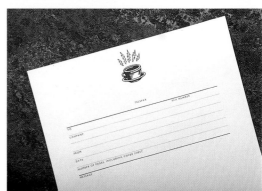

DESIGN FIRM Pentagram
ART DIRECTOR Michael Bierut
DESIGNERS Michael Bierut/
Lisa Cerveny
PHOTOGRAPHER Reven TC Wurman
CLIENT Gotham Equities
PAPER/PRINTING One color

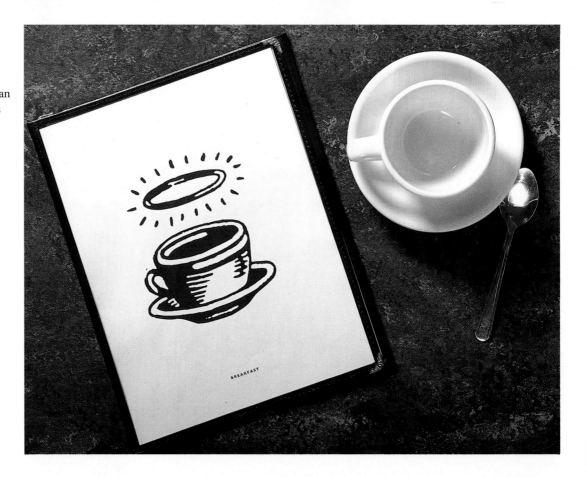

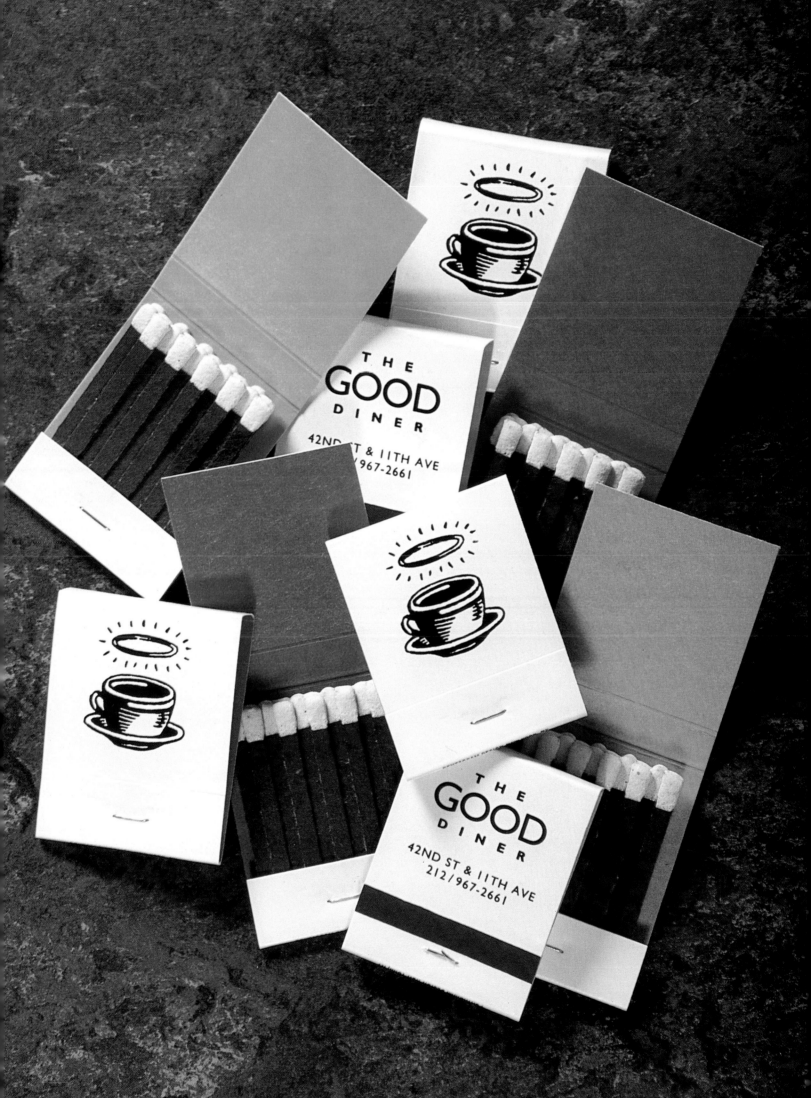

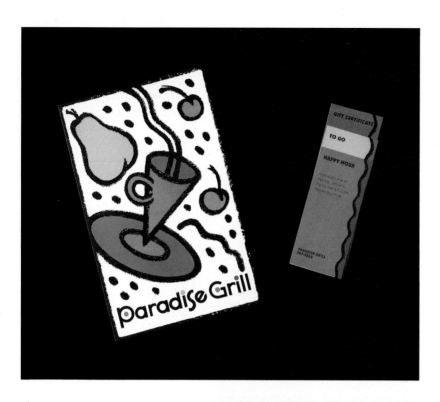

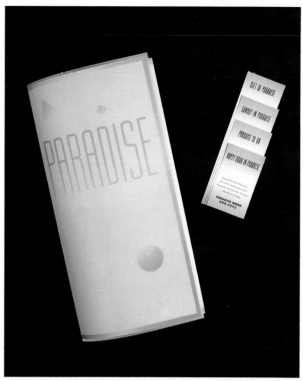

Clockwise from above left

DESIGN FIRM	Eilts Anderson Tracy
ART DIRECTOR	Eilts Anderson Tracy
DESIGNER	Eilts Anderson Tracy
ILLUSTRATOR	Eilts Anderson Tracy
CLIENT	PB&J Restaurants
PAPER/PRINTING	Four colors

DESIGN FIRM	Eilts Anderson Tracy
ART DIRECTOR	Eilts Anderson Tracy
DESIGNER	Eilts Anderson Tracy
ILLUSTRATOR	Eilts Anderson Tracy
CLIENT	PB&J Restaurants
PAPER/PRINTING	Six colors

DESIGN FIRM	Eilts Anderson Tracy
ART DIRECTOR	Eilts Anderson Tracy
DESIGNERS	Eilts Anderson Tracy/ Sarah Rolloff
ILLUSTRATOR	Eilts Anderson Tracy
CLIENT	PB&J Restaurants
PAPER/PRINTING	Five colors plus UV coating

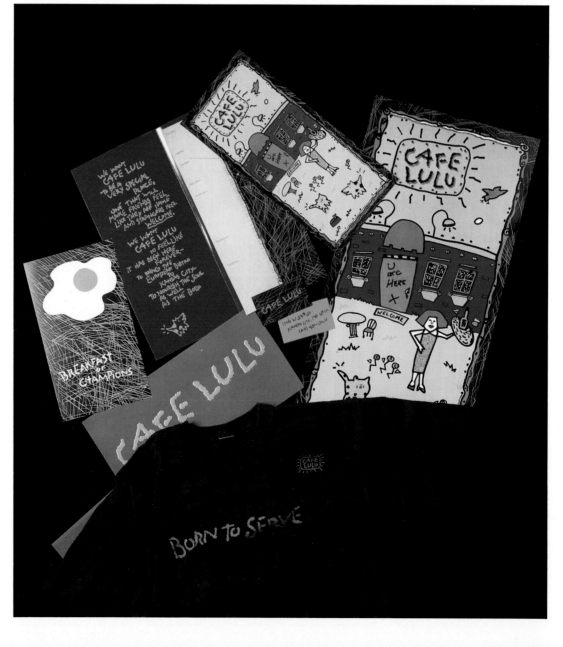

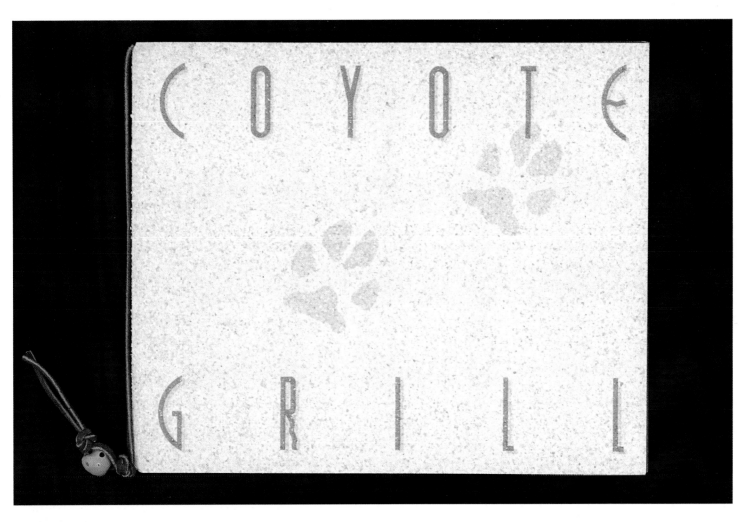

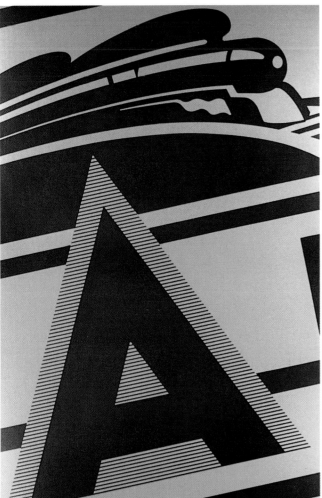

DESIGN FIRM	Eilts Anderson Tracy
ART DIRECTOR	Patrice Eilts
DESIGNER	Patrice Eilts
ILLUSTRATOR	Patrice Eilts
CLIENT	PB&J Restaurants
PAPER/PRINTING	Two colors

DESIGN FIRM	Bartels & Company, Inc.
ART DIRECTOR	David Bartels
DESIGNER	Brian Barclay
ILLUSTRATOR	Brian Barclay
CLIENT	The A Train
PAPER/PRINTING	Three colors plus varnish